The Sports Photography of Robert Riger

The Sports Photography of

preface by JOHN SZARKOWSKI

introduction by DAVID HALBERSTAM

Robert Riger

RANDOM HOUSE NEW YORK

The photographs of Robert Riger are handled exclusively by the James Danziger Gallery, New York

Designed by Wynn Dan

Printed and bound by Arnoldo Mondadori Editore, S.p.A., Verona, Italy

Library of Congress Cataloguing-in-Publication Data is available

ISBN 0-679-44513-7

24689753
First Edition

Contents

Preface

Robert Riger understands the contests that he photographs; he knows his subject matter—its simplicities and its complexities—and he feels its vantage point from which this meaning and excitement are made clear: are fixed in a graphic statement which at best is not merely a description of the action but a visual equivalent of it.

Riger is a documentary photographer; his first commitment is not to photography as such, but to the recording of those aspects of life that most fascinate him. Like hundreds of thousands of his contemporaries, Riger is drawn to the dramas of the great stadiums. Among all those thousands, perhaps none has seen the game more clearly.

He is at the same time playing a different game of his own called photography. This game requires that the player discover and clearly describe the moment and the pattern of aspect that will stand as surrogate for the other game—the moment and pattern that contain the perfection of form and the coiled tensile energy that are analogous to an act of extraordinary physical prowess. His photographs are documents, and the best of them are also pictures that now have a life of their own, and that would have given intense pleasure to George Stubbs and Winslow Homer and Thomas Eakins.

JOHN SZARKOWSKI
Former Director
Department of Photography
The Museum of Modern Art, New York

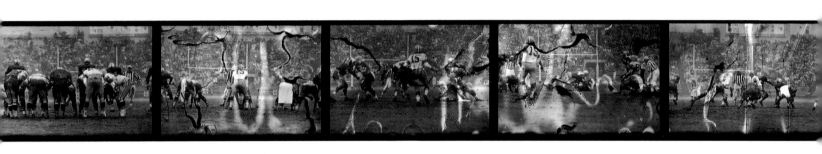

The Art of Robert Riger

by David Halberstam

■ Robert Riger was the preeminent artist of a golden age of American sports in the years after World War II. I had always thought Riger's great gift to us was his portfolio of brilliant drawings reflecting the power and drive and passion of a surpassing new generation of American athletes. But it turns out that I, like millions of other Riger buffs, was only partially right. He was an artist of dual talents. He used a camera to take the photos that allowed him to reconstruct action with great fidelity and precision in his drawings. So he sketched from dual images: the images caught by his own eye, images that had exploded in front of him and just as quickly vanished, and the images made permanent by his camera at the very same instant. He (and now we) could retire with these second images and ponder them long after the action was over, his eye, like ours, too slow for the speed of the modern sports world.

We are then doubly in Riger's debt, not just for the sketches that made the pages of *Sports Illustrated* so luminescent in his defining tour there in the Fifties and Sixties, but now, it turns out, for the equally stunning photographs that informed his work. They, like the sketches themselves, transcend mere journalism and become in his caring and talented hands, art. They give us more than a simple reminder of what happened back then, of names of players and games readily forgotten, they give us a feel of what sports (and America itself) was like at that moment.

There was something almost anachronistic about what Robert Riger achieved. The new golden age of sports was being driven more than anything else by television, and a vast percentage of the nation's newest fans had never in fact actually gone to a professional football or basketball game. They watched from their homes, or, in those early days before it was commonplace for every American to own a television set, from neighborhood bars. Television, which caught the modern dimension of sport, its ever greater speed and power, took football and then basketball, at first minor sports in the nation's eyes, and brought them to a prominence in the national psyche previously held only by baseball. Radio had loved the leisurely pace of baseball; television and the television camera loved first football and then basketball because they delivered more action per instant than baseball, and also, I suspect, because both sports were marvelous show-

9

cases for the new black athletes who were themselves responsible for so much of the additional speed in the world of sports.

Speed suddenly was of the essence; teams that accommodated most quickly to it won, those which did not, lost. Indeed Riger himself talked about not covering football for a few years and then returning to watch the Giants play briefly in the Seventies at the Yale Bowl. He was surprised by what seemed like a quantum increase in the speed of the game. It struck him that he was falling behind in his ability to capture the action. It had all speeded up so much.

In this era of more and more speed, and more and more action, there were more and more games, great games played and then almost immediately forgotten in the excitement of the next great game. Robert Riger had the unique capacity to slow the action down, to show you what you had just seen and give it a sense of permanency, lest one surpassing moment be pushed aside by the next brilliant moment. The sports that he covered reflected the hyped-up pace of modern postwar jet-age America, the fast forward of our lives; what he gave us in the midst of all that action was stop-time. He seems to have sensed that the action which was taking place in front of him was not merely sport, but a form of art as well, a kind of modern American athletic ballet performed with grace, power, and finesse. Riger was an artist thinly disguised as a journalist covering other artists thinly disguised as athletes.

I was still in college when I first saw Robert Riger's work, largely unpromoted and unhyped as it was, and was drawn to the magazine for which he worked. *Sports Illustrated* was a fledgling magazine in those days, produced (typically) by an American genius named Harry Luce who had absolutely no interest at all in sports, but who understood in some visceral way that something important was happening out there on our playing fields. Luce saw that this was a brilliant new American theater, and

that his fellow citizens appreciated something that he himself could not quite comprehend but which had its own special importance and value. Good Calvinist that he was, Luce didn't go out to the ballpark for a lazy afternoon with a bunch of pals to eat hot dogs in the sun, nor did he journey in the fall to Yankee Stadium and talk to his buddies about whether Sam Huff should or should not blitz against the Cleveland Browns. But he did know when something important and profound was taking place in the society around him. His fellow Americans were enjoying their leisure time as their forefathers had not, and if he himself was not interested, millions of others were.

Today the word "magazine" has an entirely different connotation from the one I grew up with. Increasingly, it implies an hour-long television program, produced if at all possible on the cheap, in which one celebrity from the world of journalism-entertainment interviews a celebrity from the entertainment world. The word magazine was different back in the Fifties and Sixties. It connoted language and ideas and art, all blended together under the watchful eye of a skilled editor, and the early *Sports Illustrated* was one of the great showcases of literary and photographic art. As it attracted some of the best writers, photographers, and artists to its pages, so it also attracted a generation of serendipitous readers who were pulled to the magazine by its literary and artistic excellence. In that marvelous era Riger was one of its signature figures.

He worked simply in a simpler time. Sports would soon become big business, each professional league a thriving billion-dollar industry all its own. As its players became ever bigger stars (and youthful millionaires), more and more rules were drawn up designed to separate the players from the crowds who watched them and the journalists who covered them. But when Riger first began to cover sports, there was little evidence of all the glory and fame and financial reward to come. No one, Riger once

noted, was doing sports in the days when he began. Access to players was comparatively easy. He remembered working as a photographer-illustrator when the Giants had just started playing at Yankee Stadium: there was only one other photographer working alongside him, a man using an old Graflex camera, a device that seemed to have been left over from the set of *The Front Page.*

The athletes of that time were warriors largely unheralded by the society around them, men living in their own world and bonded by the rules of their own culture, their egos not yet inflated by skyrocketing salaries and constantly escalating fame. Riger could move easily among them, and if he so chose, capture them unaware in their own natural habitat. They were approachable and at ease with this gifted artist who had an empathy for them and for what they did. He was good because he knew what he was doing, understood the games, understood both the talent and the passion of the athletes, knew how both to give and receive respect, and managed to catch what was best, most purposeful, and most emotional about their world. Once during an interview someone listed the different qualities that marked his work, the intelligence, the anticipatory sense that came from knowing the games. Riger, not a boastful man, listened and added one more quality. "And caring," he said. He was a consummate professional, fastidious and demanding. When a television interviewer discussed with him with great enthusiasm the brilliant photo Riger had taken of Johnny Unitas during a championship game, the interviewer made the mistake of referring to it as the 1957 championship game. Riger very quietly accepted the praise, but with no show of ego, and no attempt at a put-down, he also demurred and corrected the interviewer. "The 1958 championship game," he said.

John Szarkowski says that Riger's best photos remind us of the work of Winslow Homer and Thomas Eakins, and I both agree and am pleased by that suggestion; I am a huge Eakins fan and an enthusiast of rowing and I have sometimes wished that I had a Riger photo of oarsmen at play, if play is the correct word. For the truth is that I have always wanted an Eakins. As I looked through this portfolio I was moved by what Riger has given us: a monumental record of modern American warriors at work. Our great athletes are not only gifted but passionate, and it is their trademark that at critical moments they try to surpass their personal best. I think Riger has captured that quality, that sense of passion and excellence and audacity, whether it is in the photo of an injured Mickey Mantle, swinging and missing with full power extension during the 1960 World Series, a photo that Riger himself called simply "Pain"; or of Jackie Robinson dancing off third, fire and ice, threatening and unconquerable, challenging, it seems, not merely the pitcher and catcher but perhaps the entire society around him; or of Kyle Rote and Frank Gifford in their T-shirts in the locker room before a game, warriors made curiously mortal by how ordinary they seem just before they don their gladiators' armor. The signature photo of the book is on the cover, the photo of the quintessential warrior at the end of a hard day's work: Forrest Gregg, the great offensive lineman for the Green Bay Packers, is cloaked in mud at the end of a game in Kezar Stadium. (Incidentally, this photograph would be impossible to take in all too many stadiums today because of the use of artificial carpets.) The gentlemen who put this book together were kind enough to offer me one photograph from it as a gift, and, much to my own surprise, for I know almost nothing of and care little about horse racing, I have chosen the one of the jockey Tony DeSpirito. There is no action in the photo. DeSpirito exists without movement, but he is the athlete personified, the power and will in him self-evident. It is not only a stunning photo, it is probably as close as I will ever get to owning an Eakins.

Yankee catcher Thurman Munson in what will be his last game in New York. Yankee Stadium, 1979.

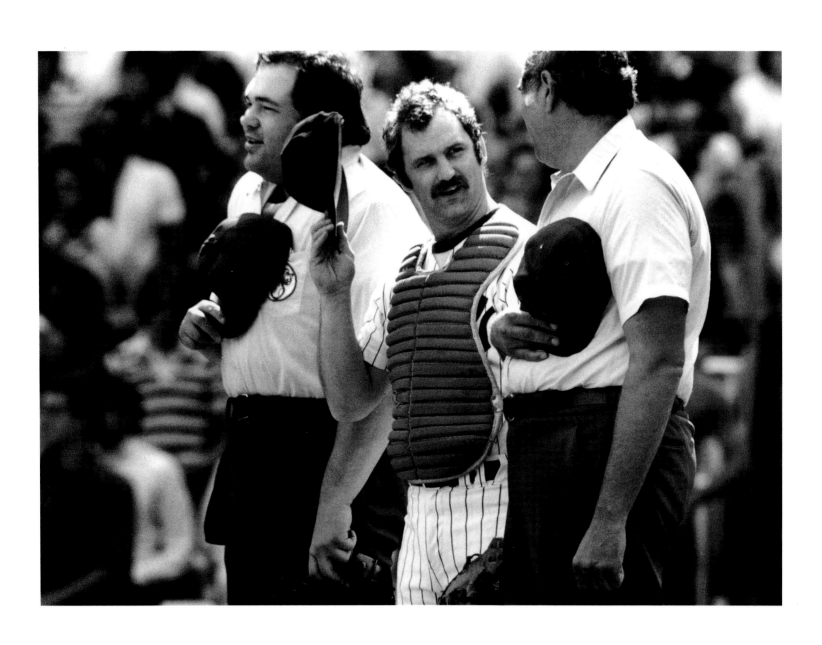

Jim Bunning, Detroit right-hander. Briggs Stadium, Detroit, 1960.

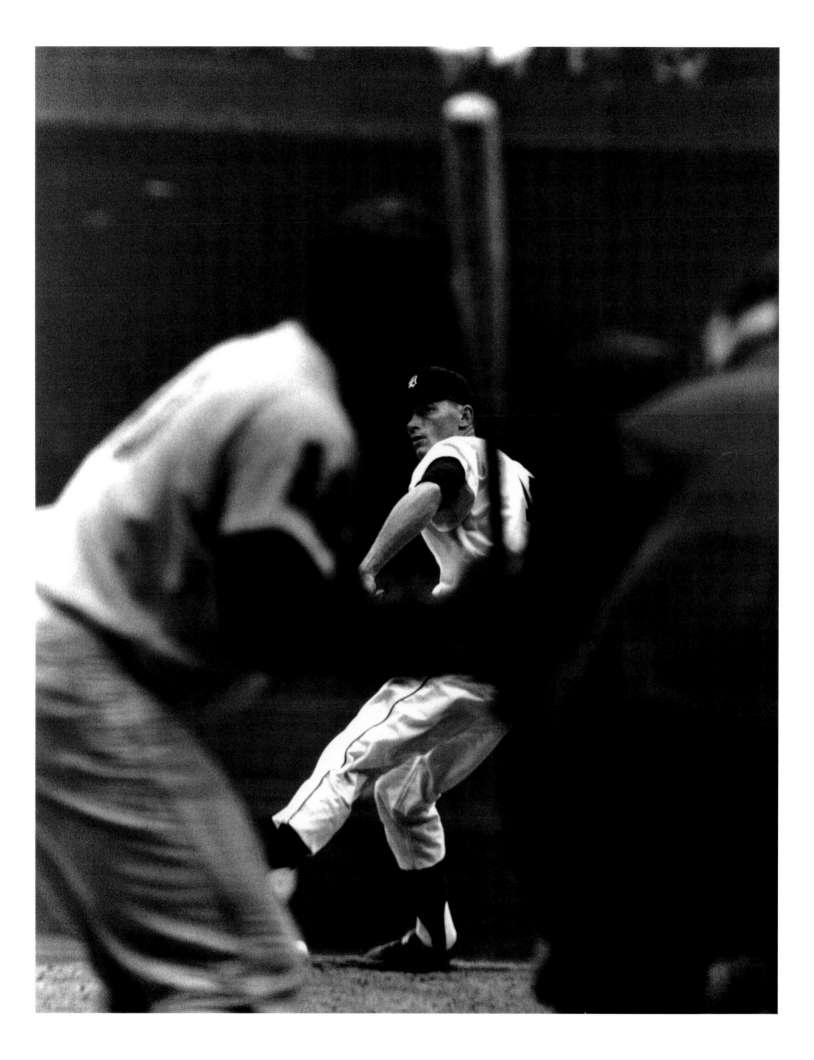

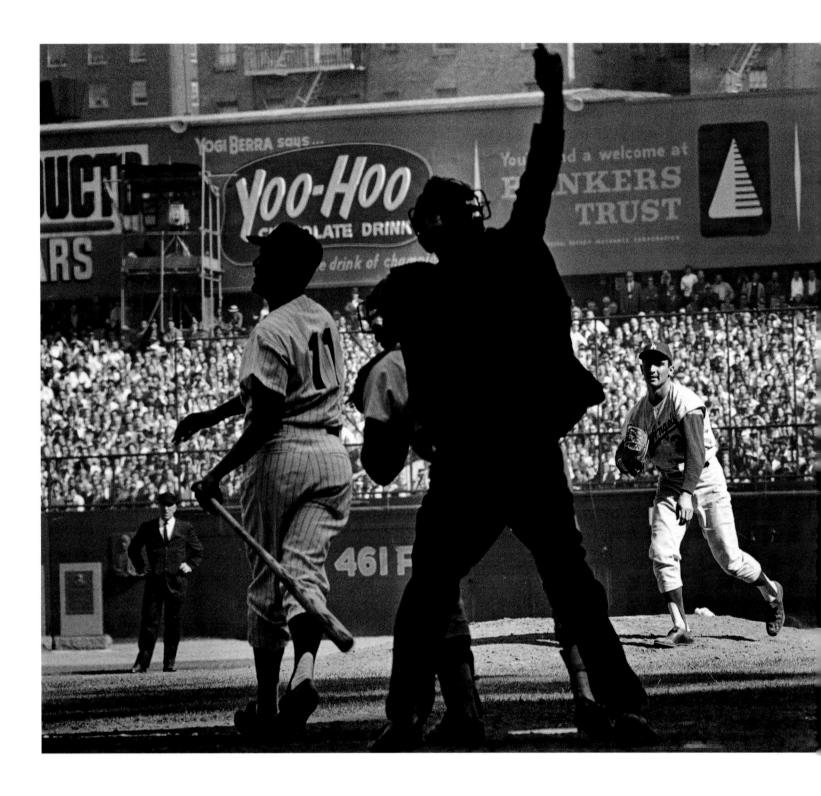

Dodger pitcher Sandy Koufax strikes out Yankee
pinch-hitter Harry Bright to win the first game of the World Series, 1963.

"Willie Mays Steals Third." Ebbets Field, Brooklyn, 1955.

Following pages: Roberto Clemente, Pittsburgh Pirates.

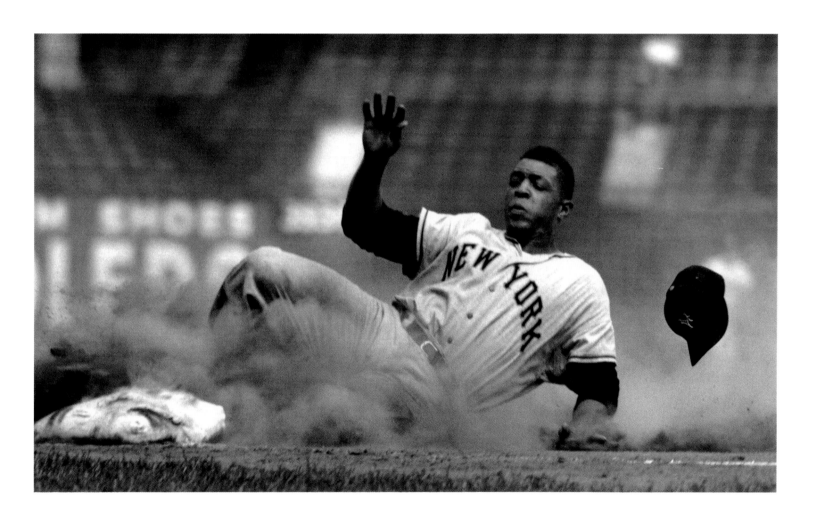

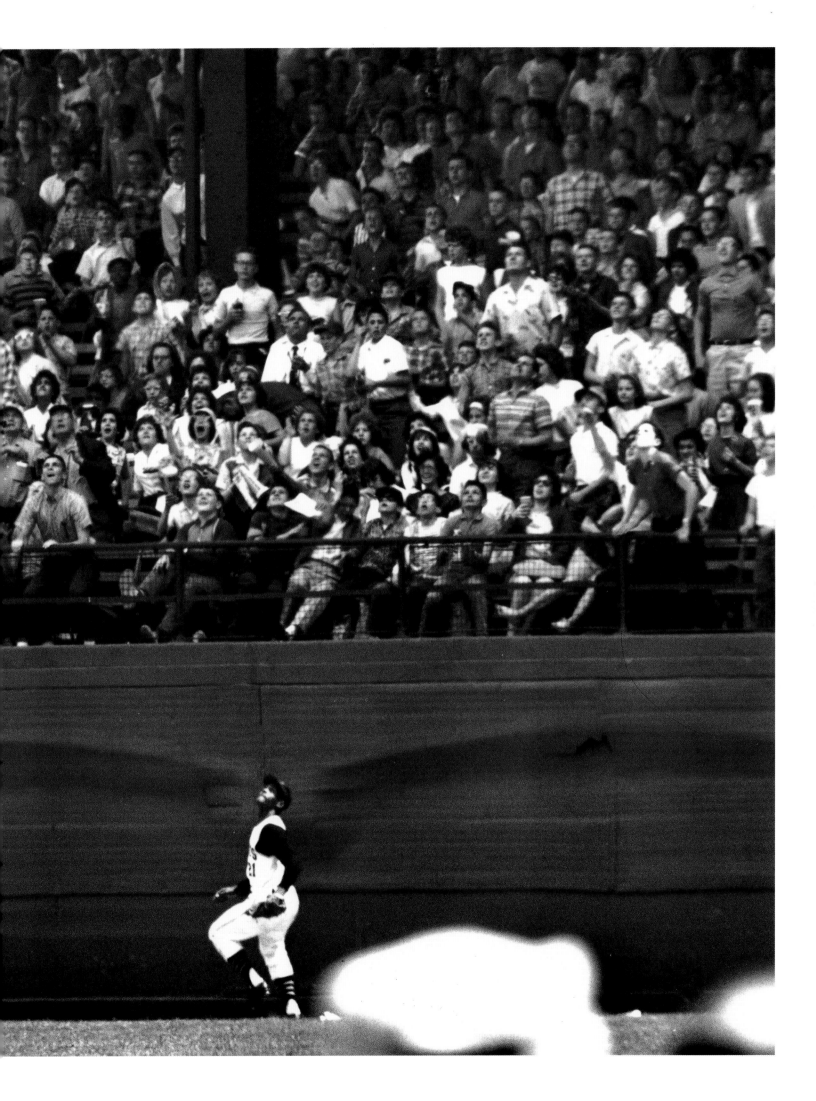

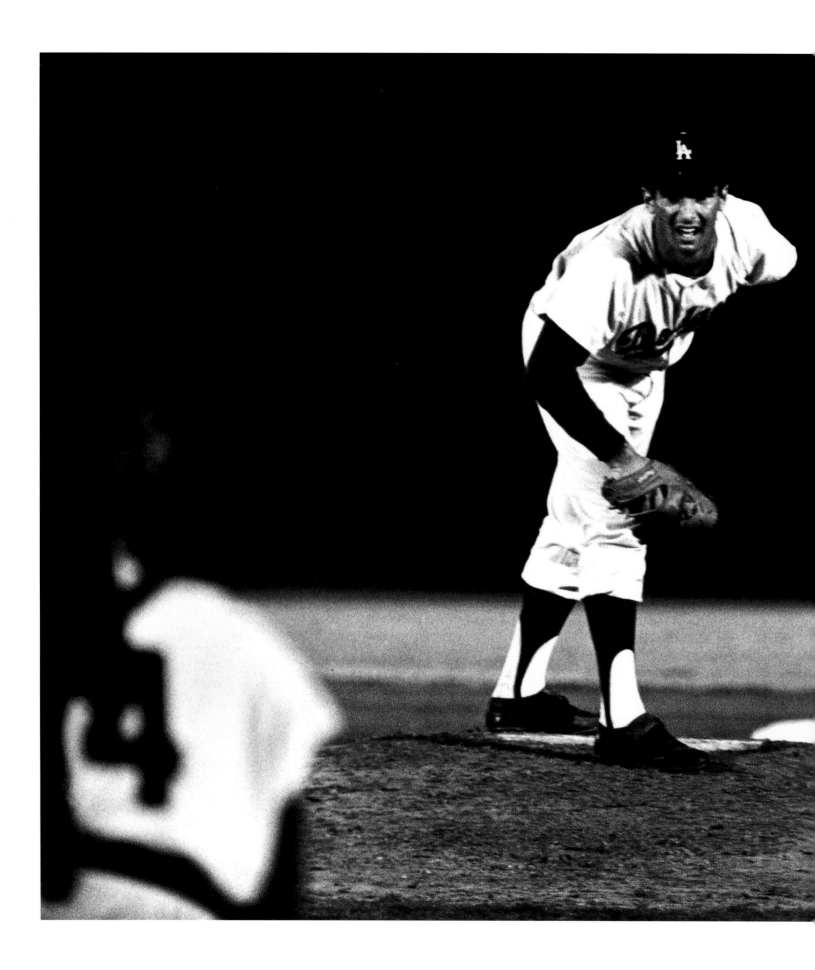

Sandy Koufax pitches at night against the San
Francisco Giants. Los Angeles Coliseum, 1961.

Following pages: "Pain." Mickey Mantle in
the 1961 World Series. Cincinnati.

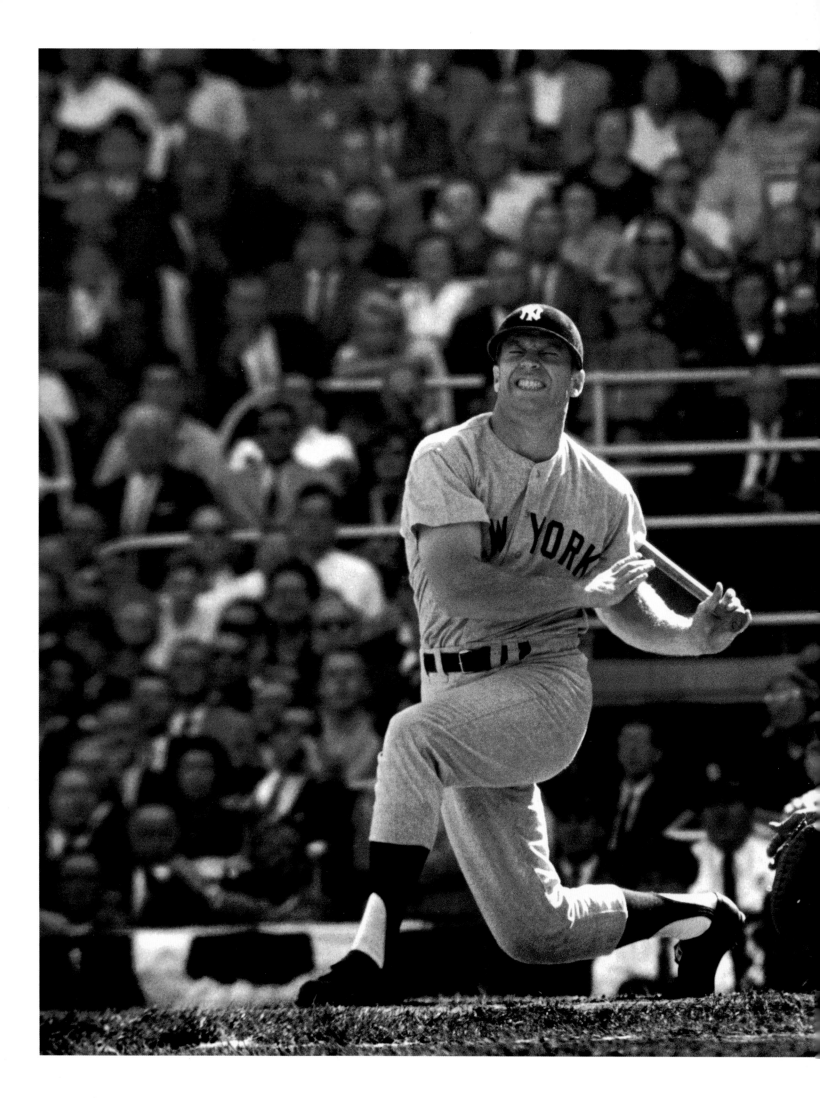

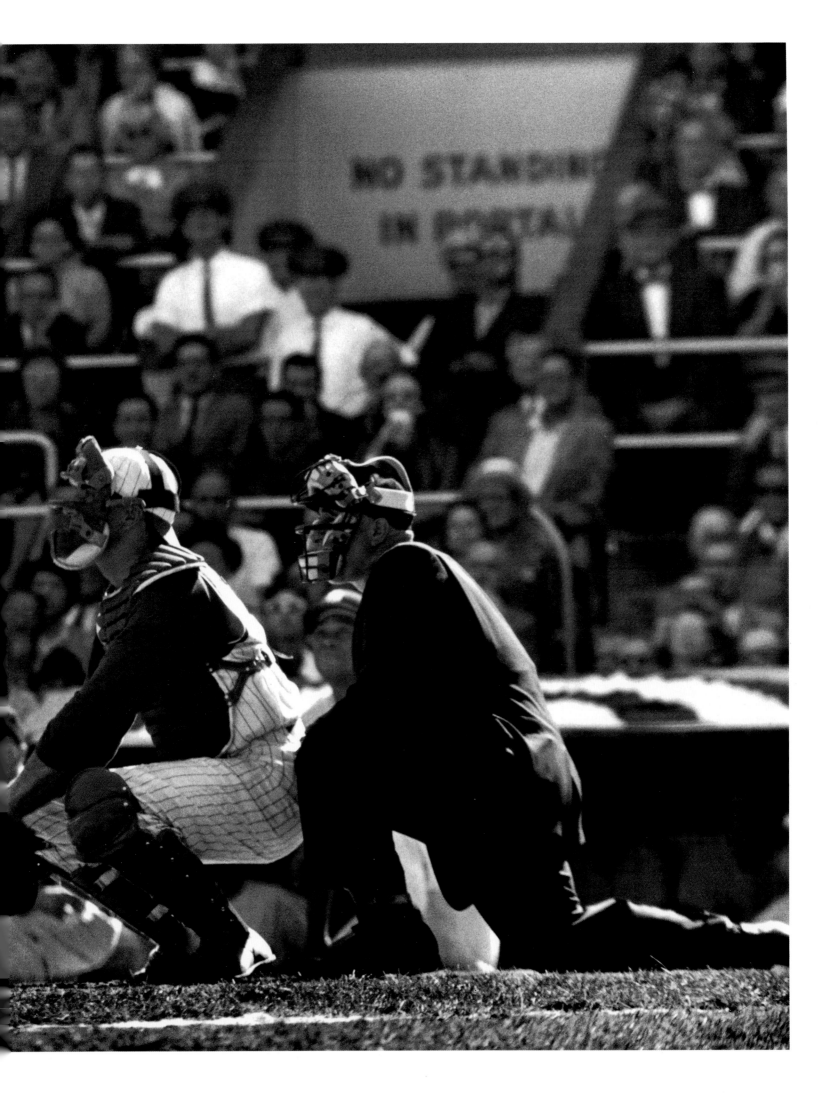

Yankee short stop Tony Kubek tags Roberto Clemente at second in the 1960 World Series. Forbes Field, Pittsburgh.

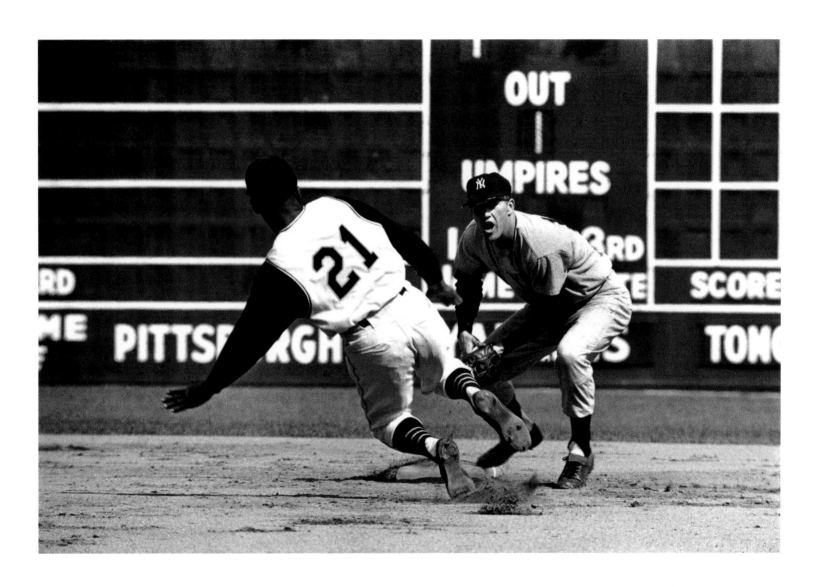

A runner collides with the
catcher at home plate, kicking
the ball loose to score.
Briggs Stadium, Detroit, 1960.

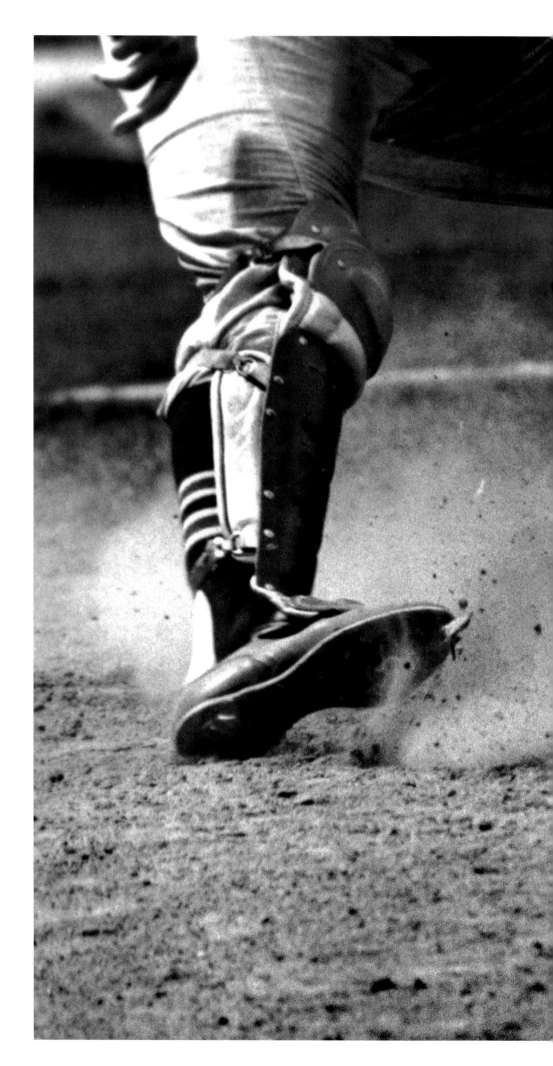

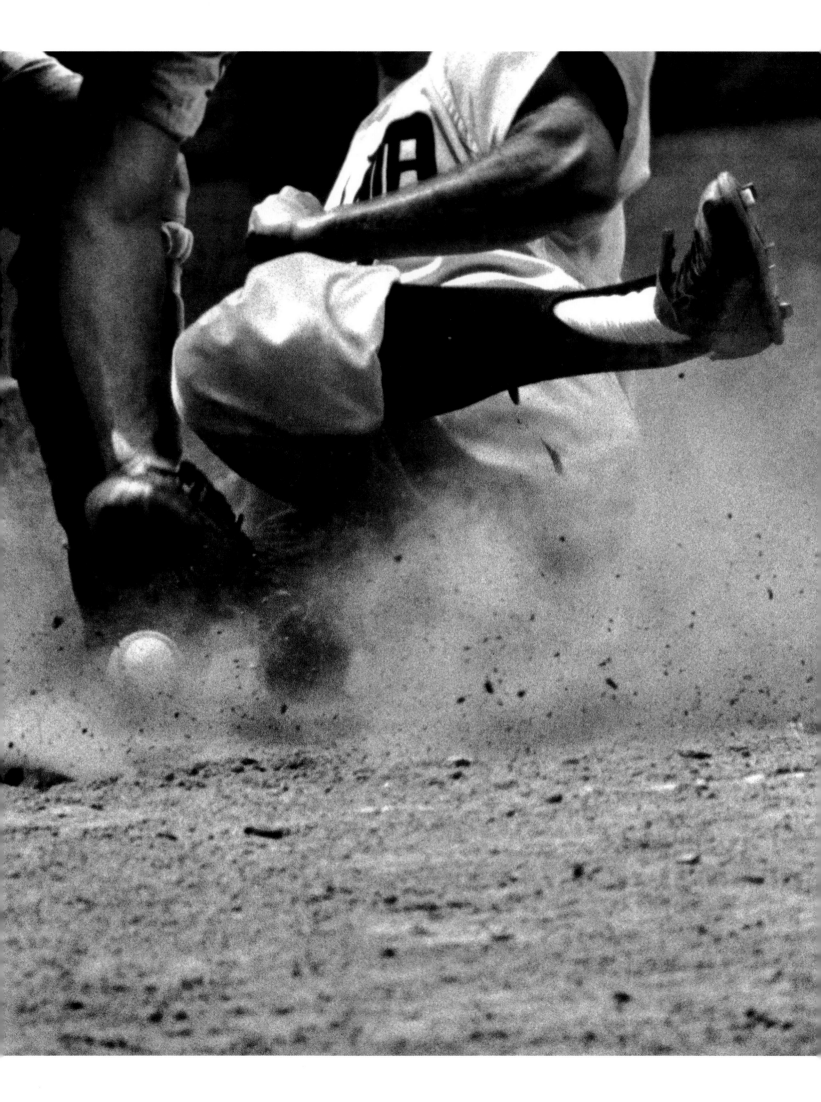

The first regular-season game at the Houston Astrodome. Giants and Astros, 1965.

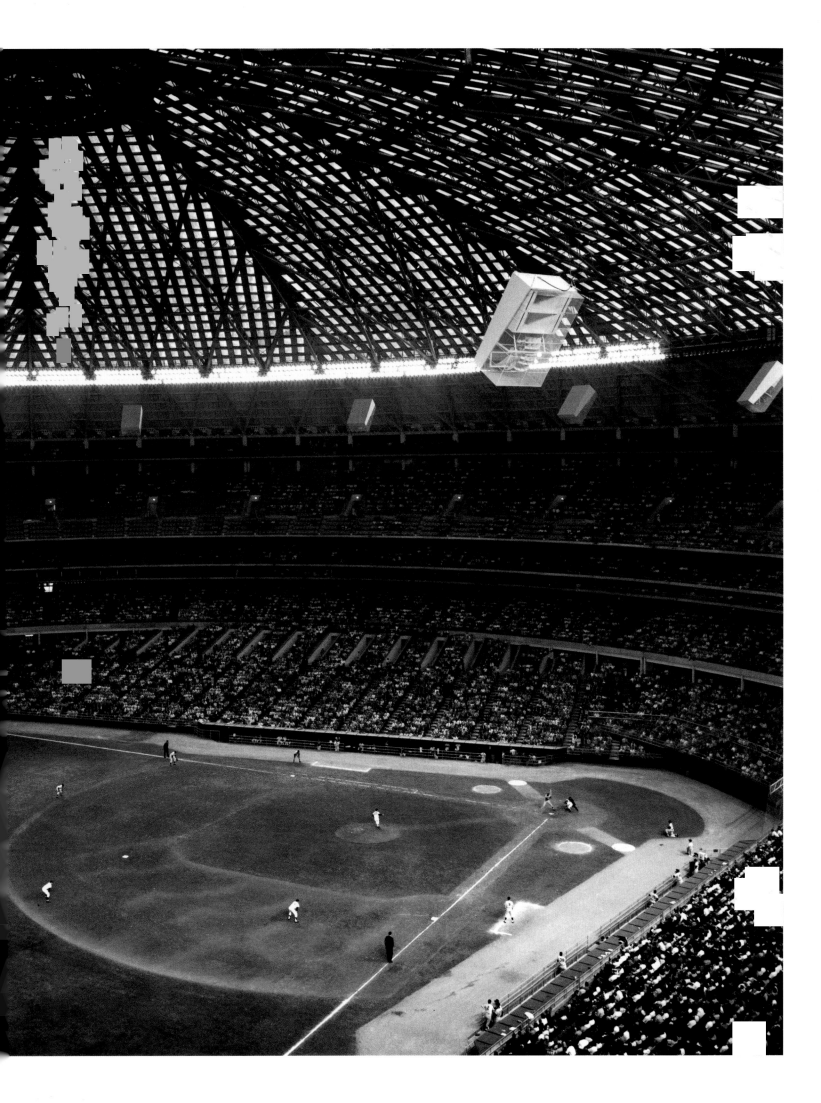

Warren Spahn winds up for Milwaukee on his fortieth birthday, 1961.

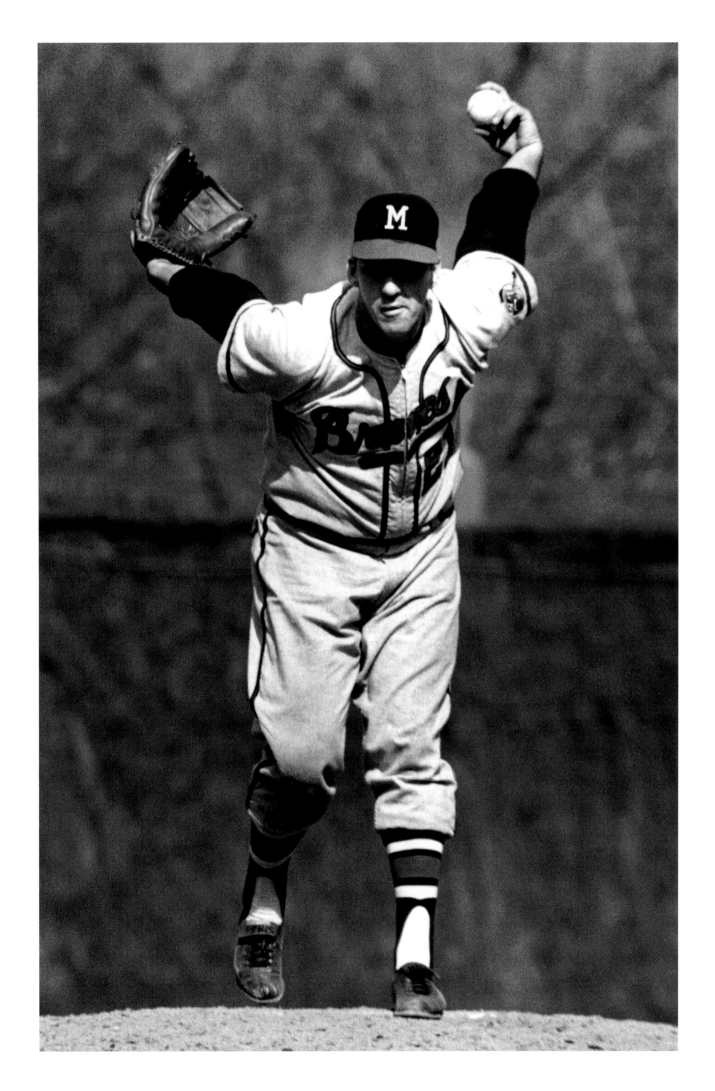

Braves slugger Hank Aaron. Pittsburgh, 1960.

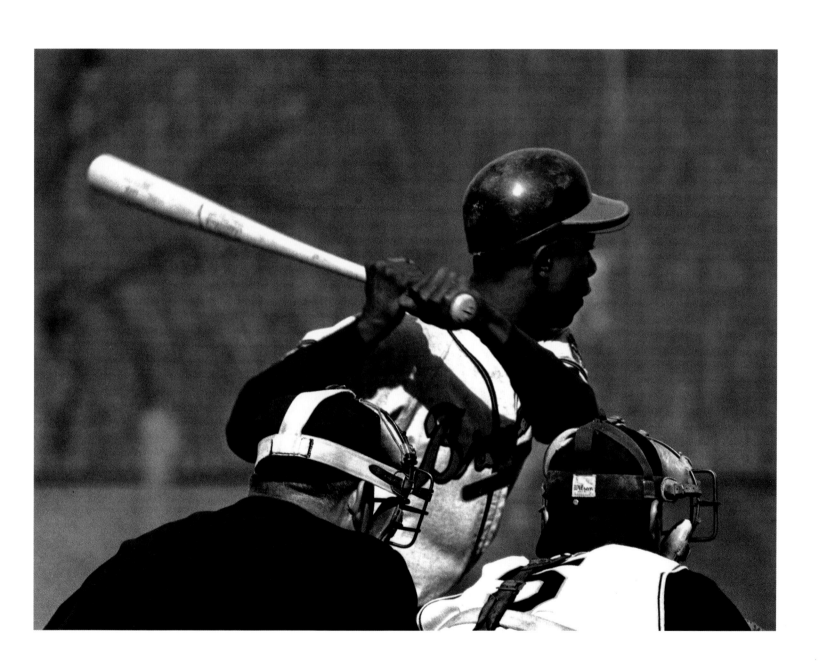

American League umpire Hank Soar. Detroit, 1961.

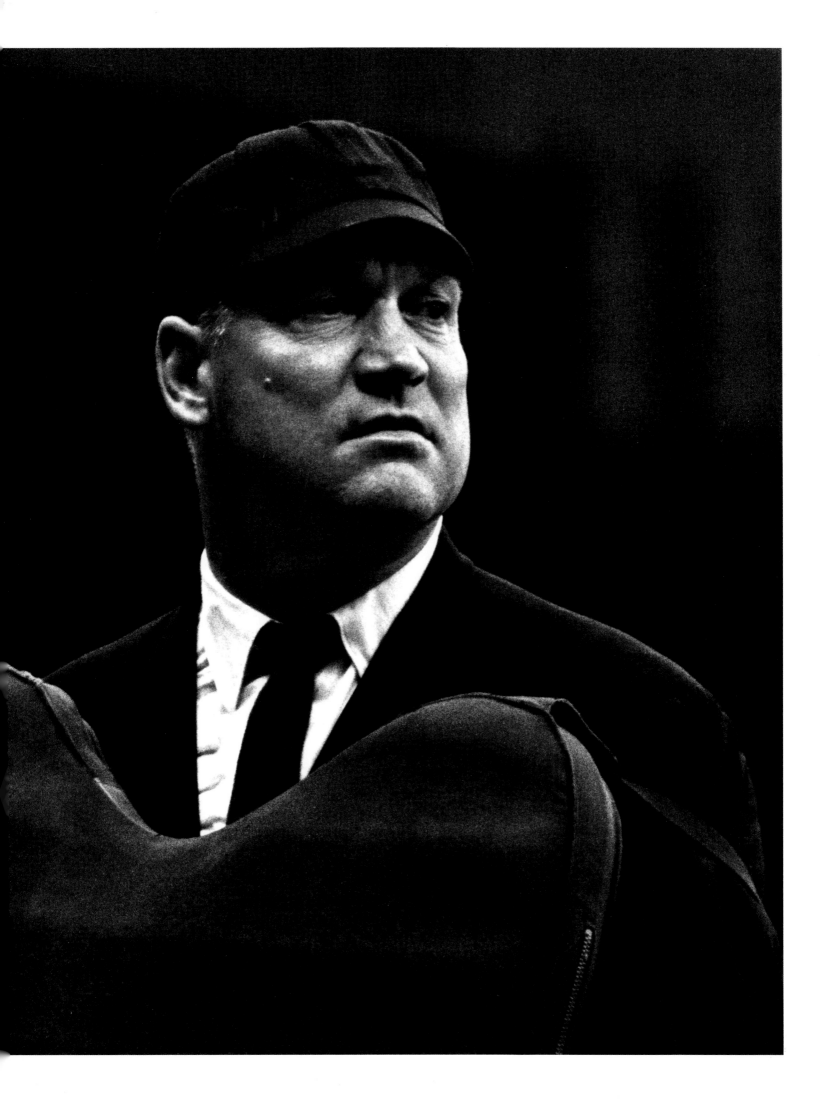

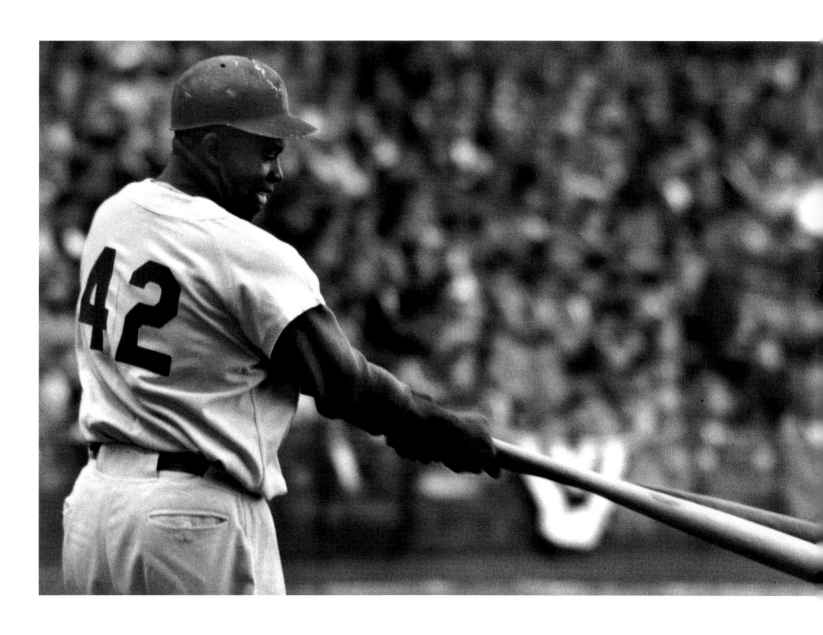

Jackie Robinson in the World Series on-deck circle. Ebbets Field, Brooklyn, 1955.

Willie Mays connects for the San Francisco Giants. Crosley Field, Cincinnati, 1962.

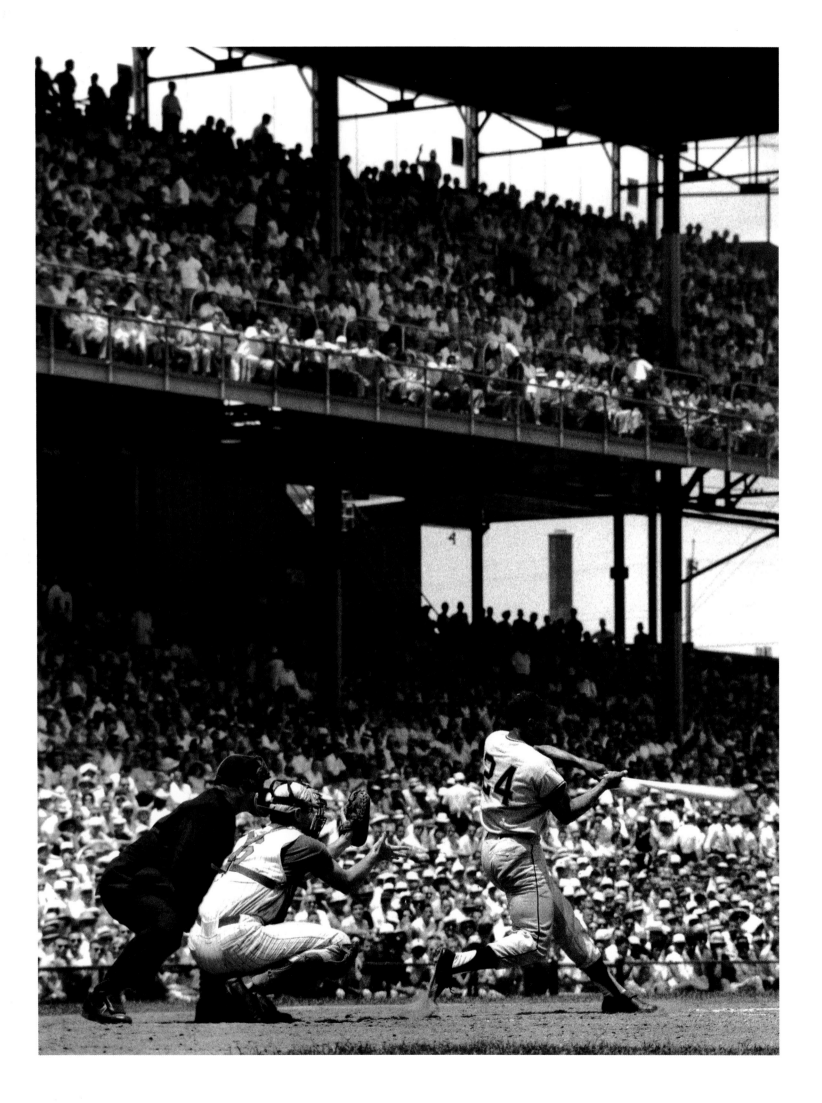

Casey Stengel.

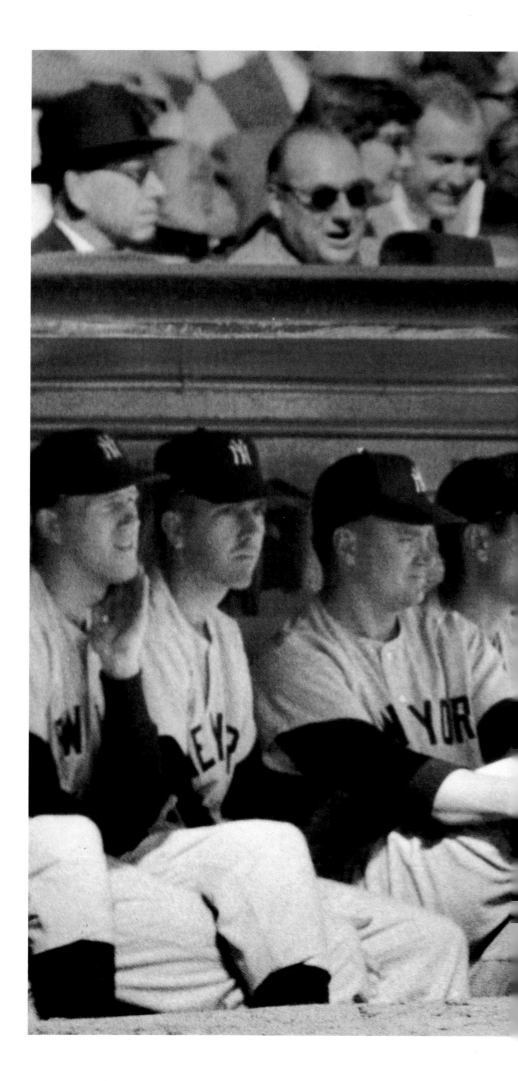

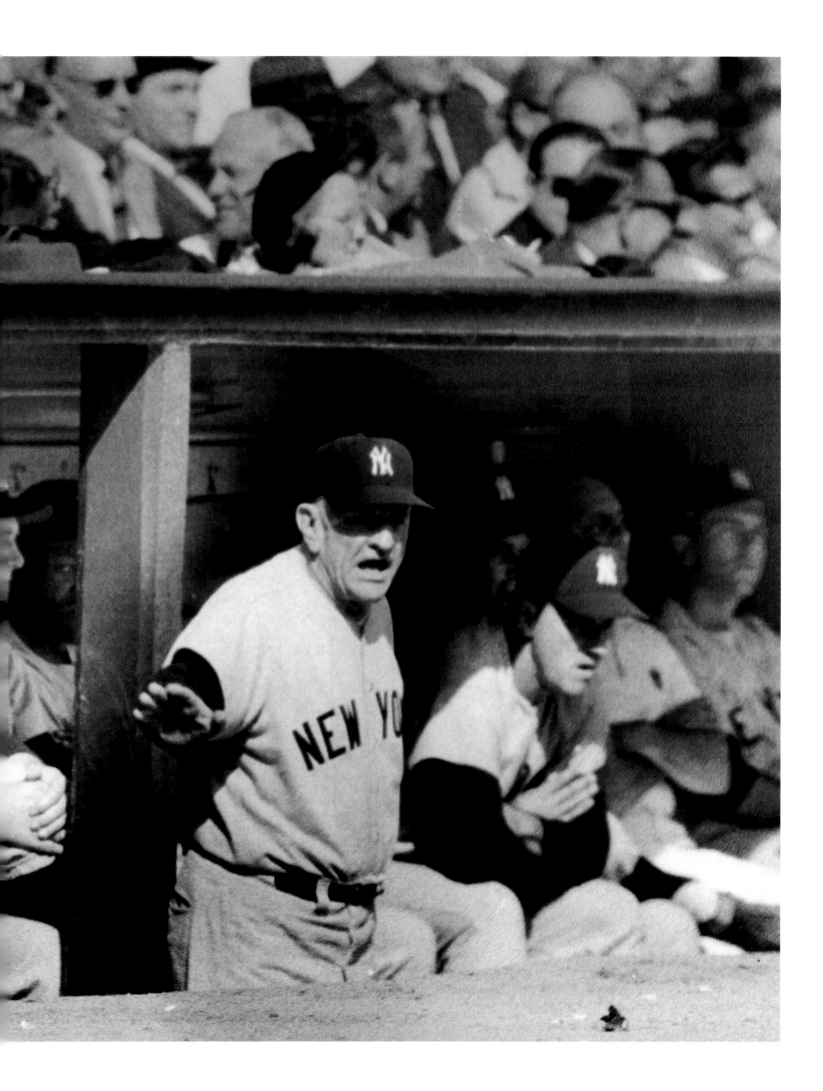

Milwaukee Braves' rookie Hank Aaron is greeted at
home plate by Del Crandall. Ebbets Field, Brooklyn, 1954.

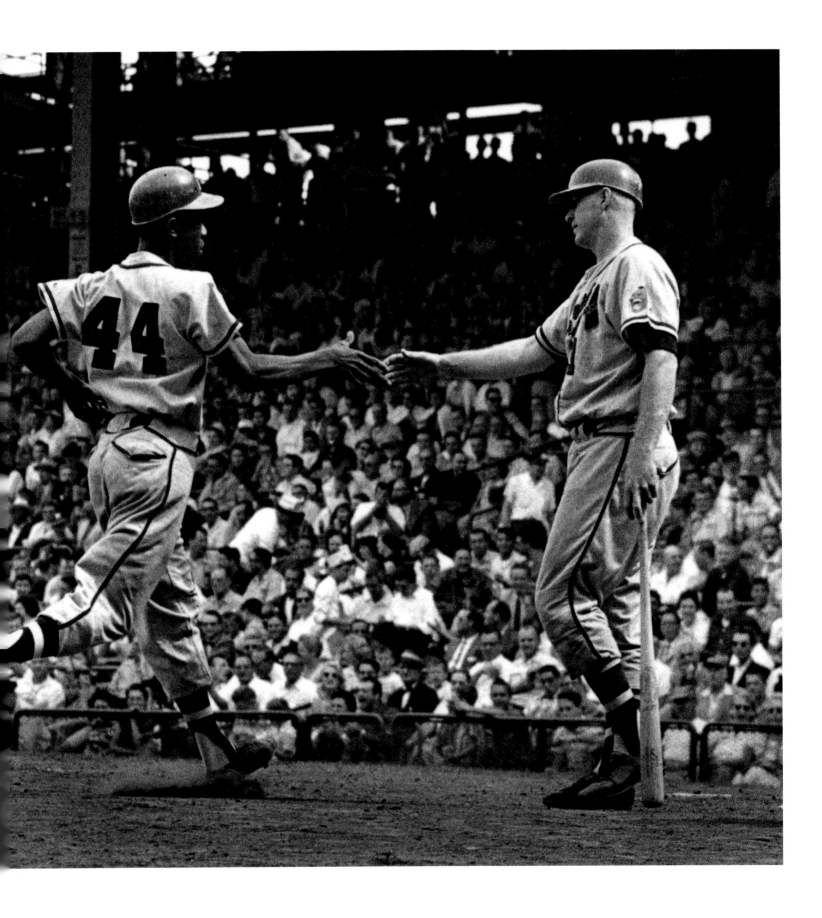

San Francisco Giants' pitcher Juan Marichal in the playoffs against the Dodgers, 1962.

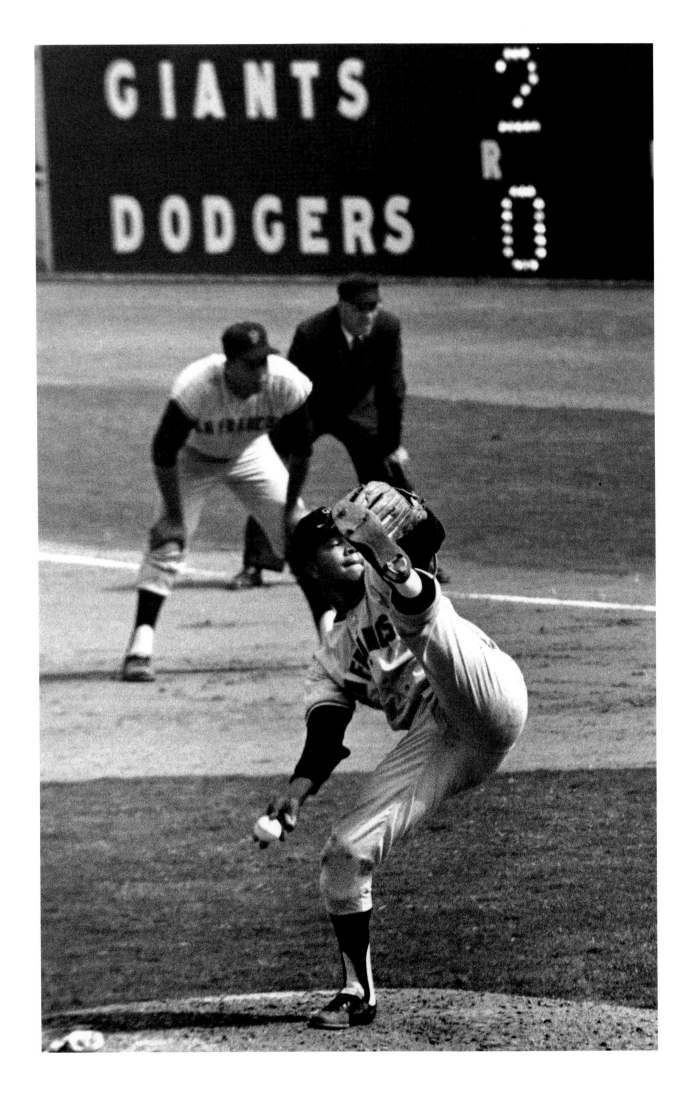

The Mets' bullpen at the Polo Grounds, New York, 1962.

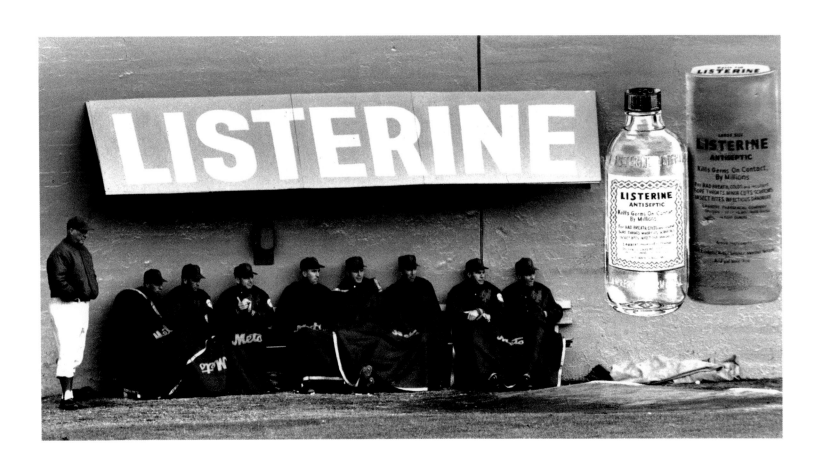

Los Angeles Dodgers' left-hander Johnny Podres in the second game of the 1963 World Series, Yankee Stadium.

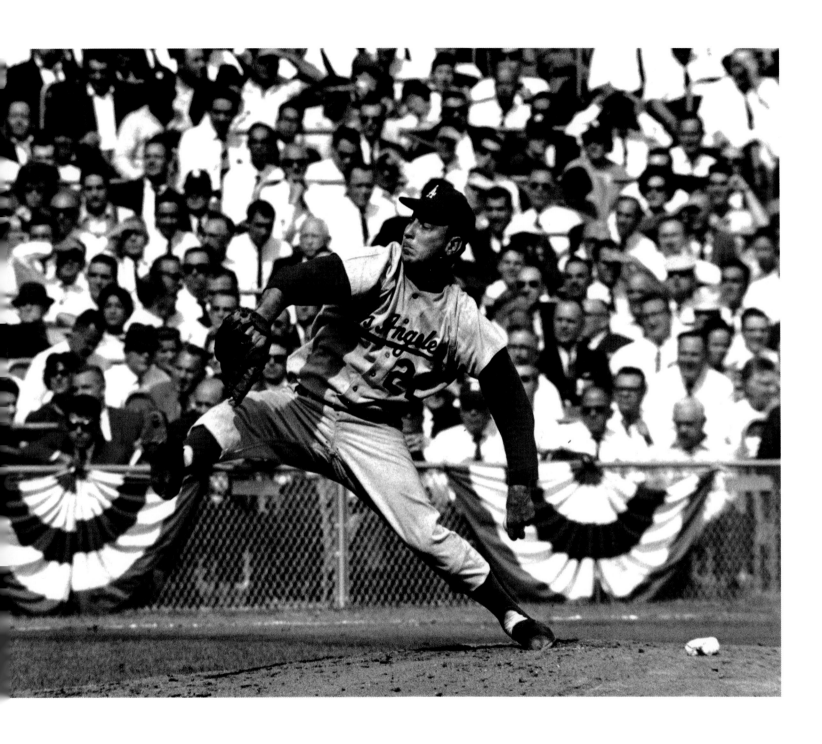

Cincinnati Reds' catcher Johnny Bench.

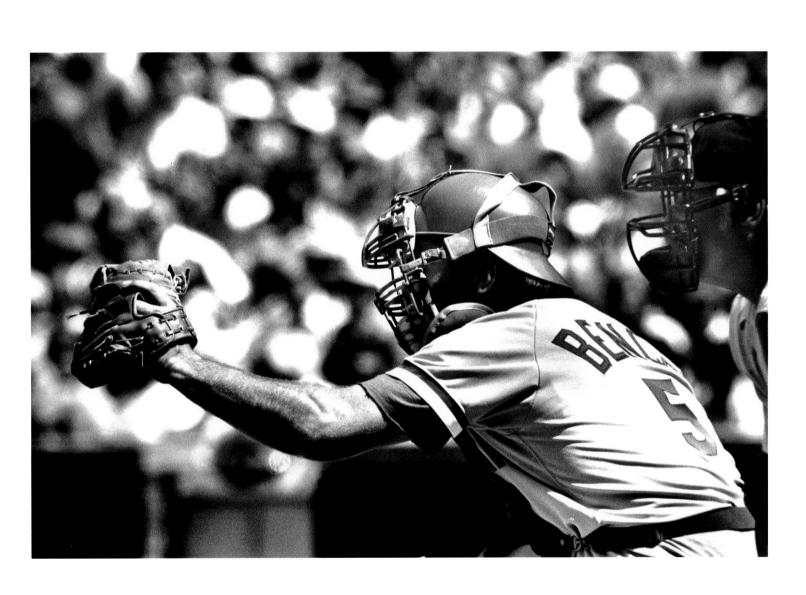

Mickey Mantle hits a home run. Yankee Stadium, 1960.

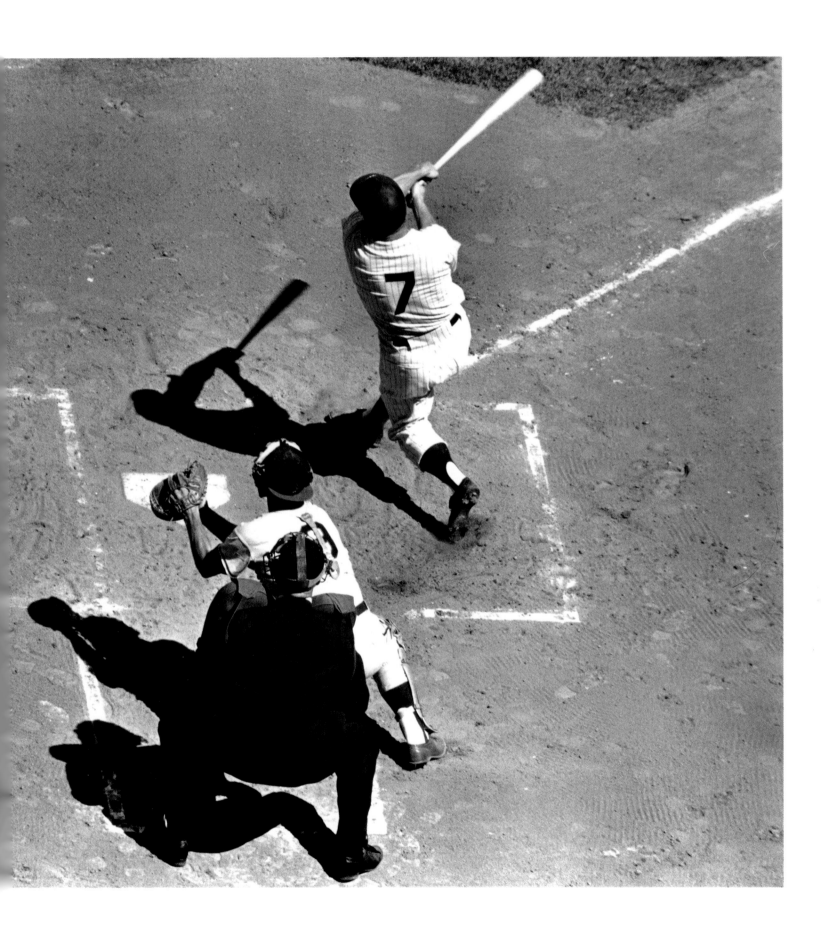

Willie Mays gets a triple. Ebbets Field, Brooklyn, 1955.

Following pages: Brooklyn catcher Roy Campanella watches Stan Musial hit a home run over the Ebbets Field fence. Brooklyn, 1957.

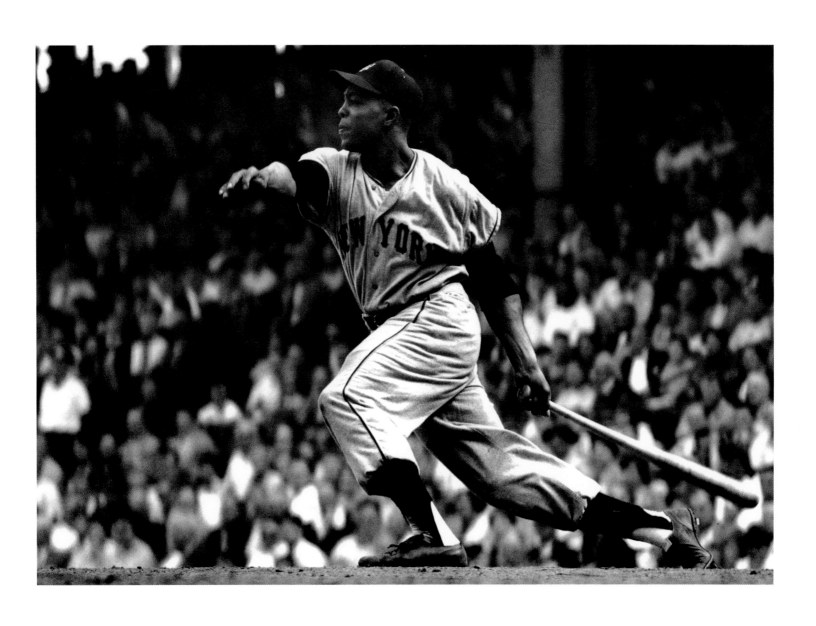

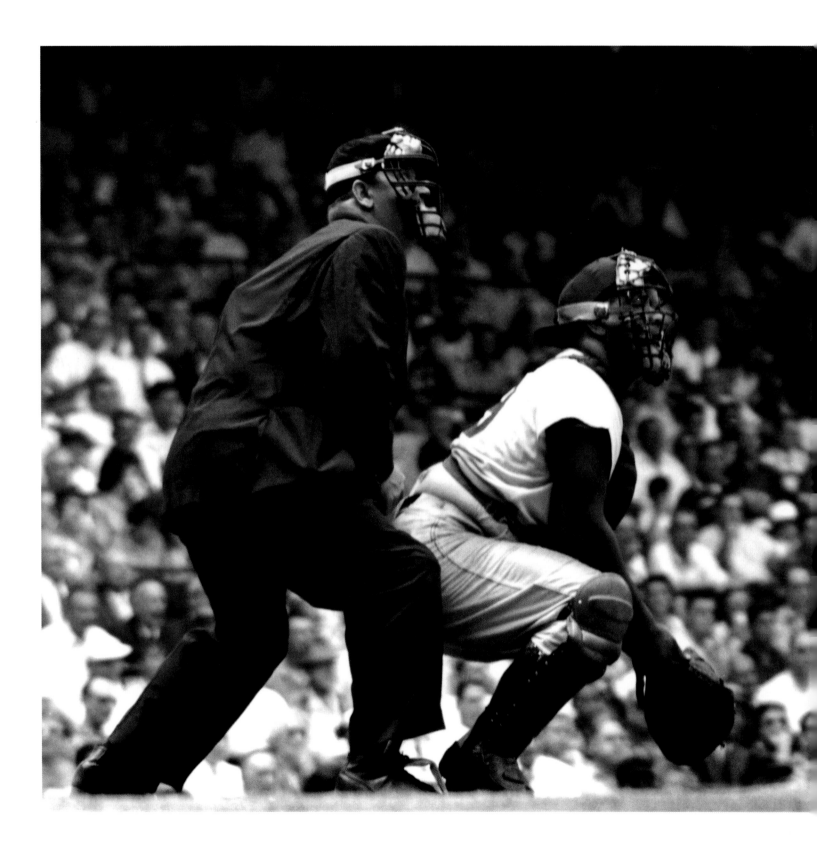

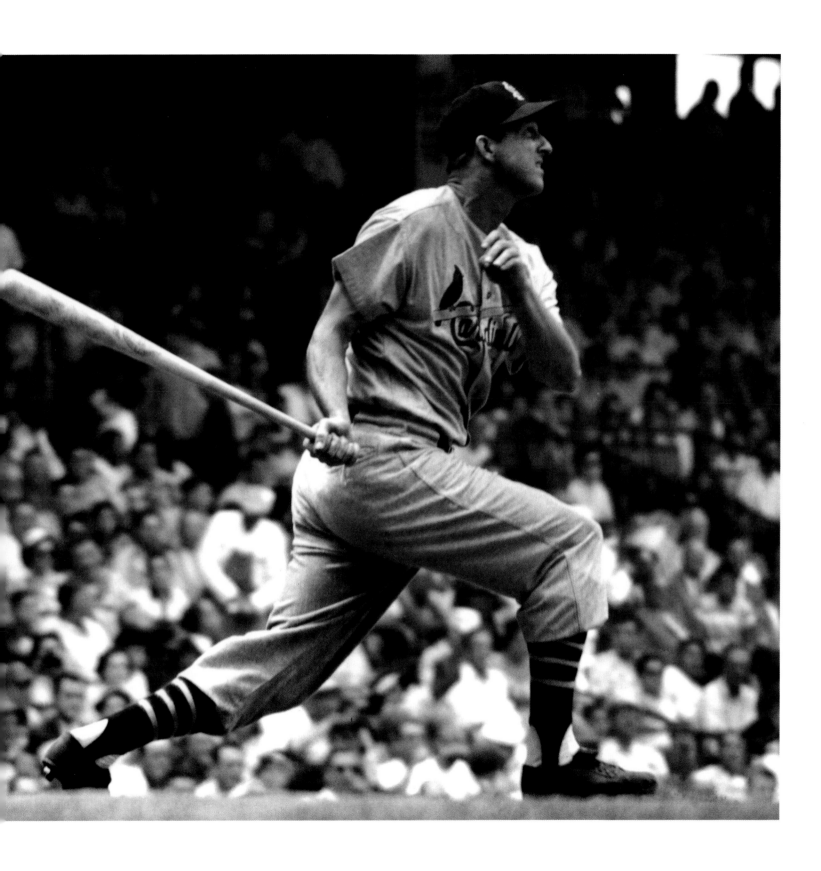

"The Great Intimidator." Jackie Robinson takes a huge lead off third base at Ebbets Field, Brooklyn, 1956.

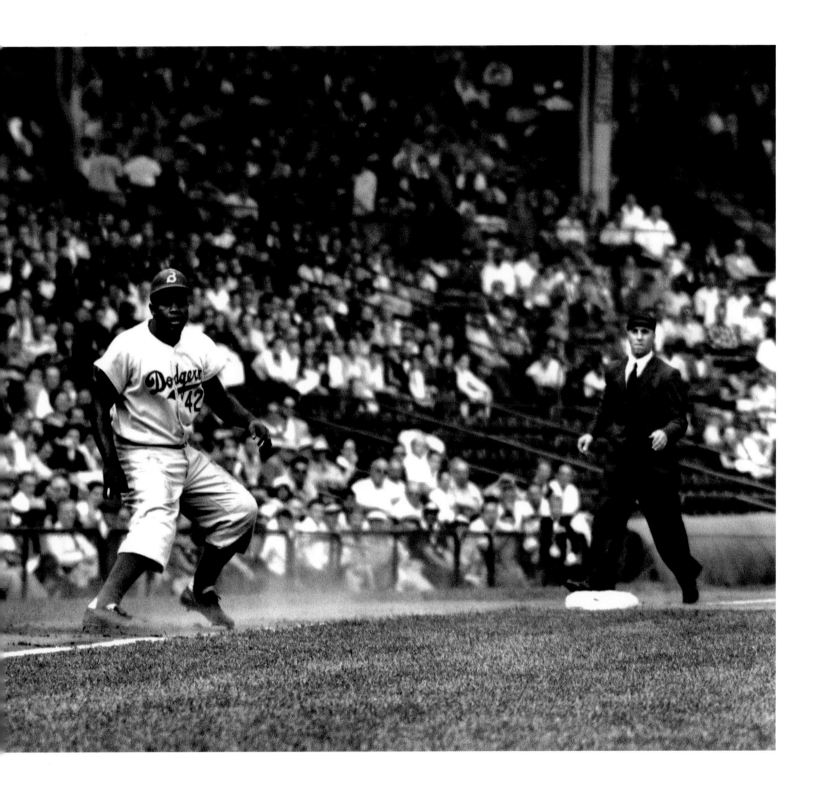

Mickey Mantle is congratulated by Bobby Richardson and Roger Maris for his sliding deep-center catch, 1961.

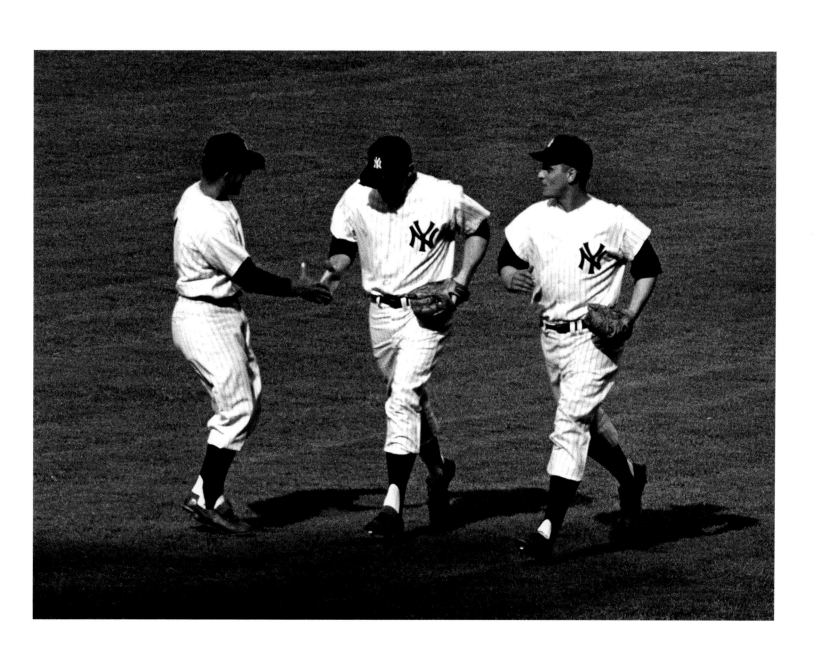

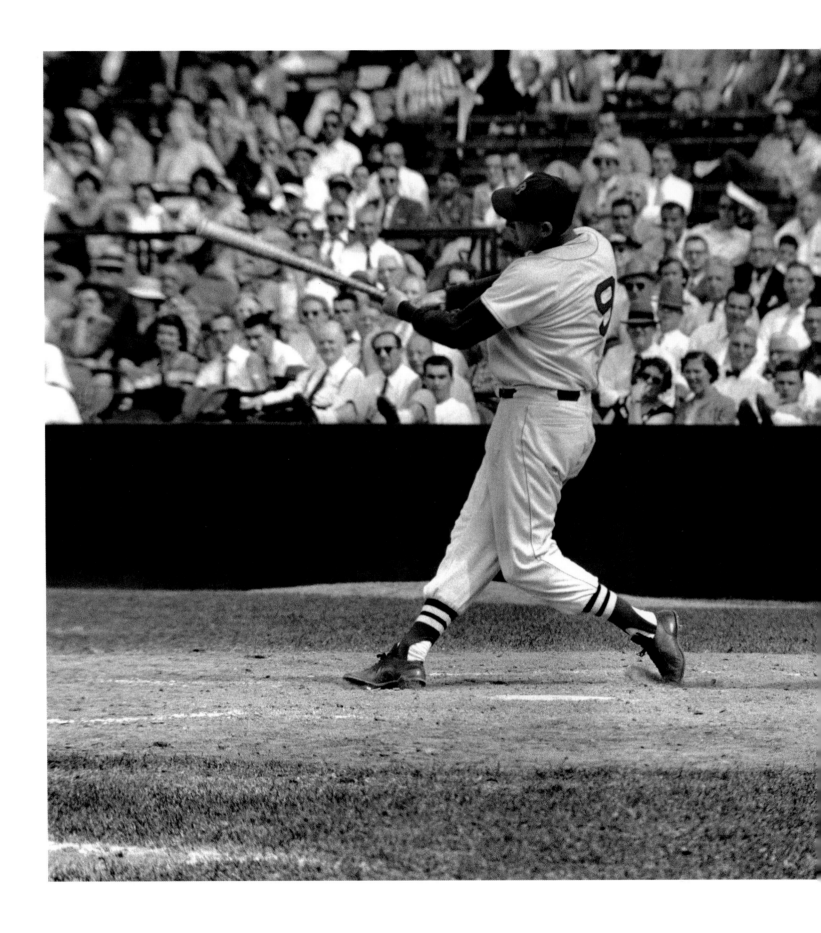

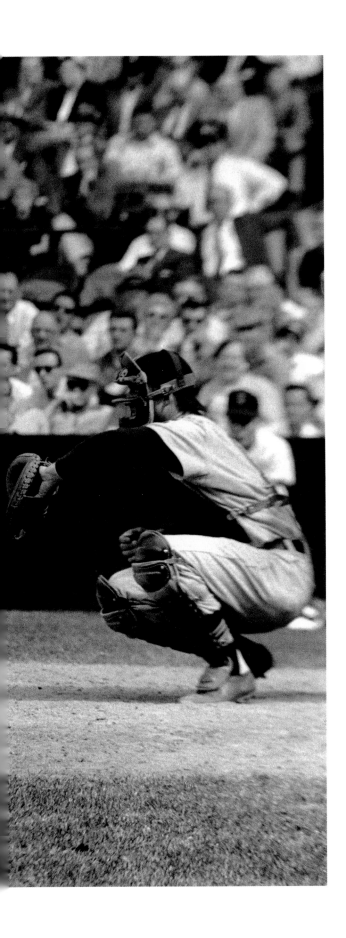

Ted Williams connecting for a home run for the
Boston Red Sox. Fenway Park, Boston, 1958.

Roy Campanella and Yogi Berra after a high-and-inside pitch, 1955.

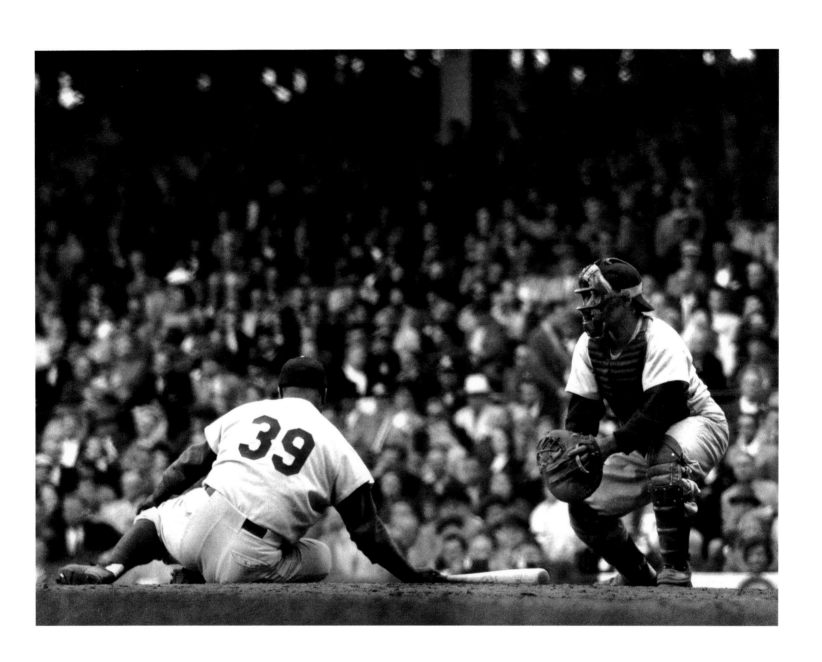

Mickey Mantle greets Roger Maris
after a home run. Detroit, 1961.

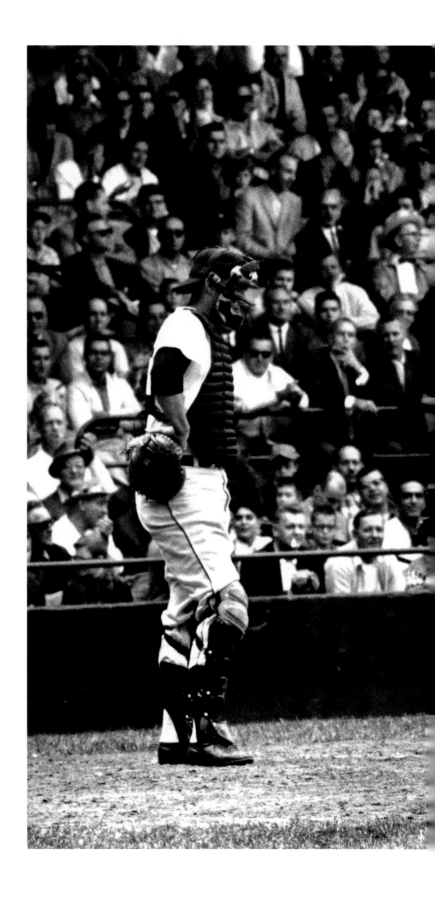

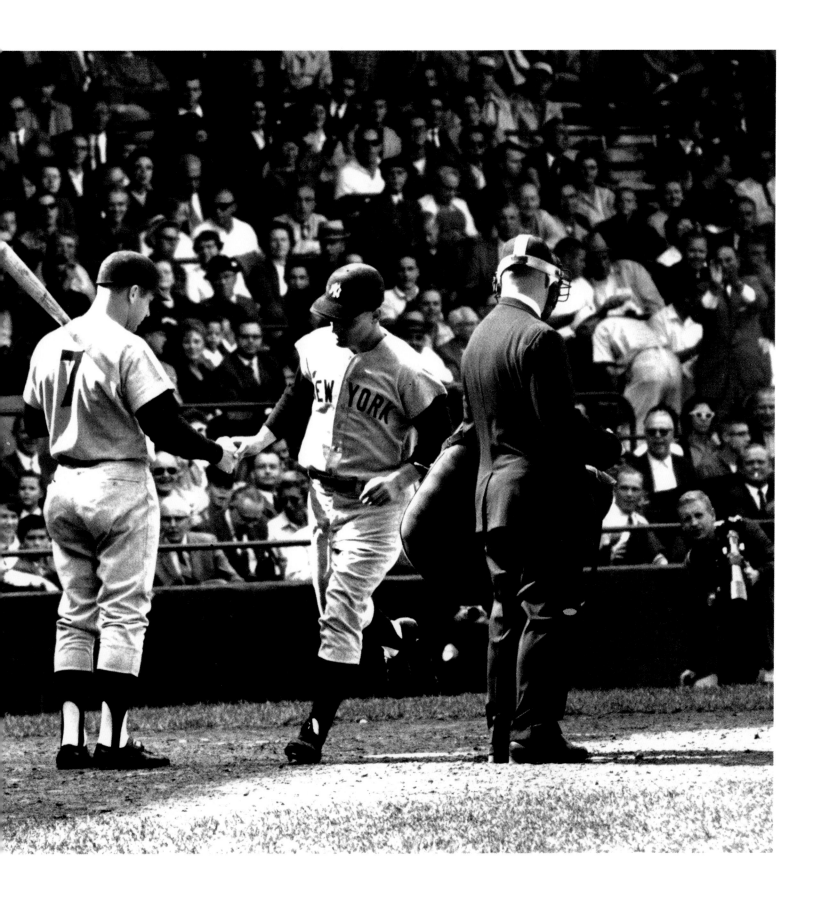

Cincinnati third baseman Pete Rose follows through on a base hit, 1976.

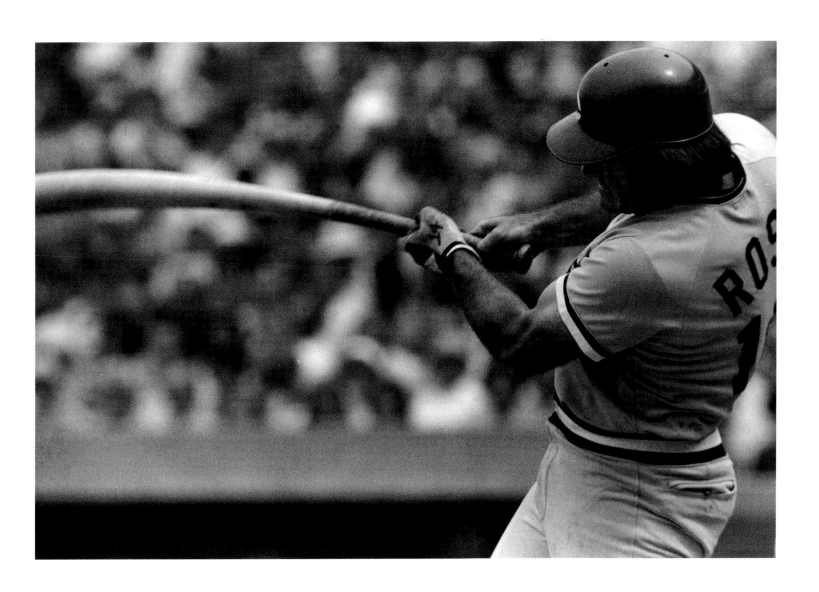

The New York Mets defeat Boston in the sixth game of the 1986 World Series.

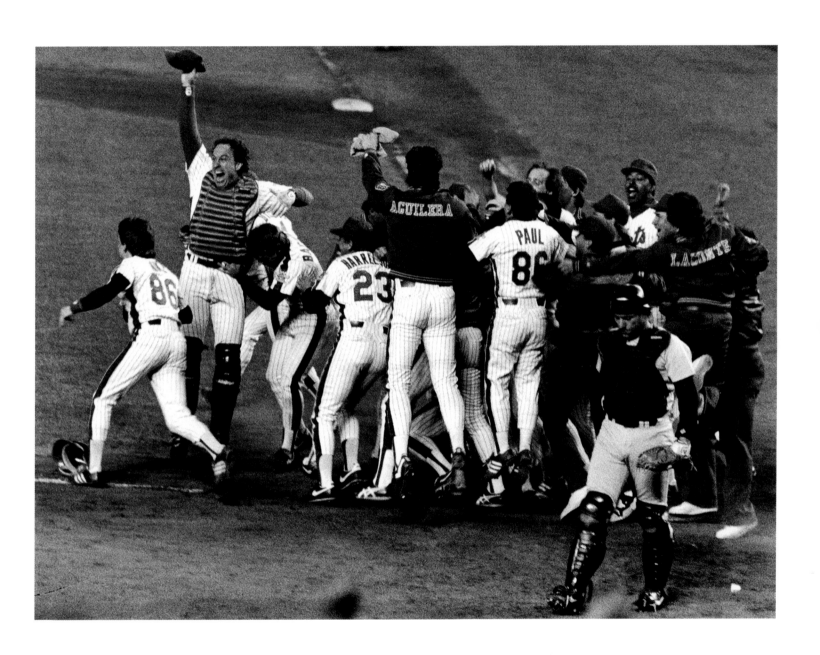

Willie Mays talking to reporters in the Giants' dressing room after
San Francisco beat Los Angeles in the 1962 National League playoffs.

Yankee manager Billy Martin.

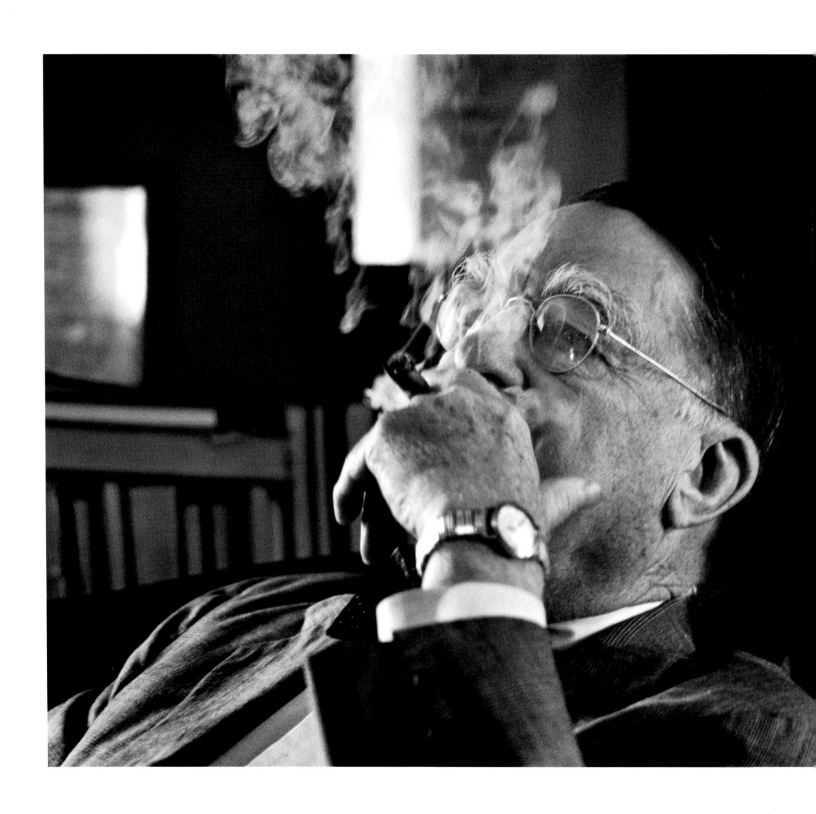

Branch Rickey, "The Mahatma," 1962.

Kyle Rote and Frank Gifford in the New York Giants' locker room before the championship game with the Baltimore Colts. Yankee Stadium, 1958.

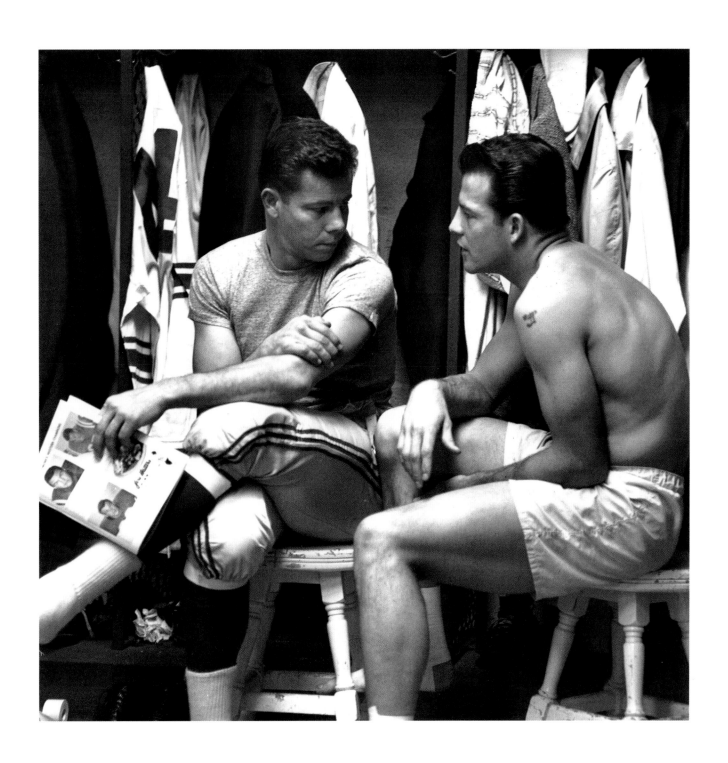

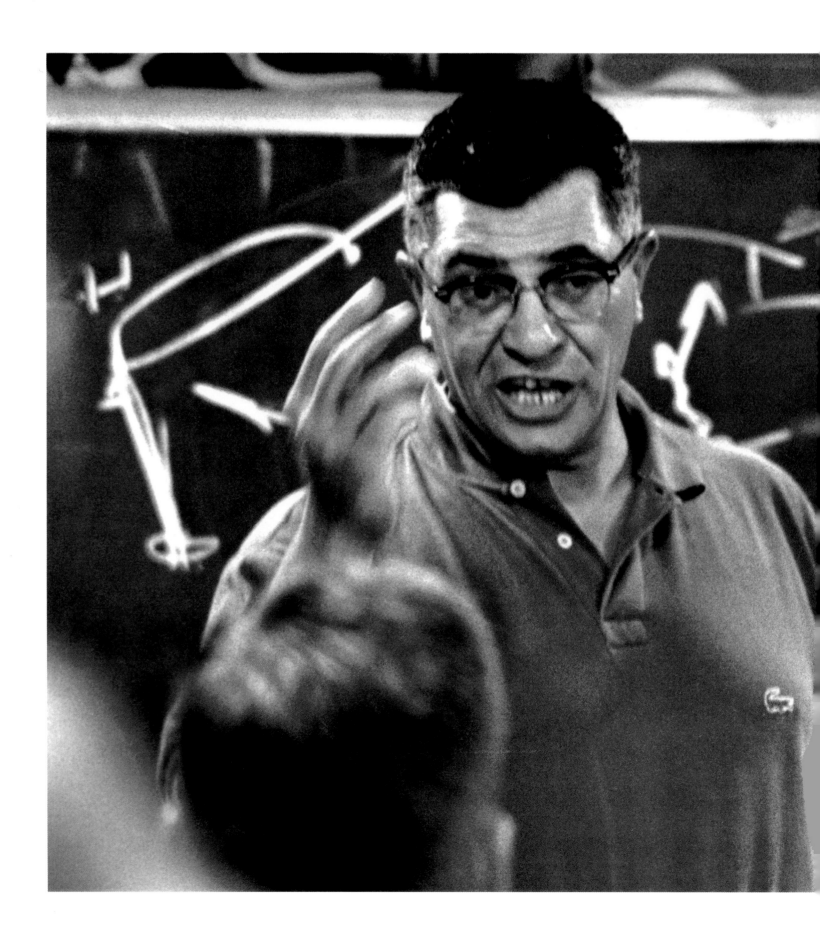

Green Bay Packer coach Vince Lombardi
in a private strategy session, 1962.

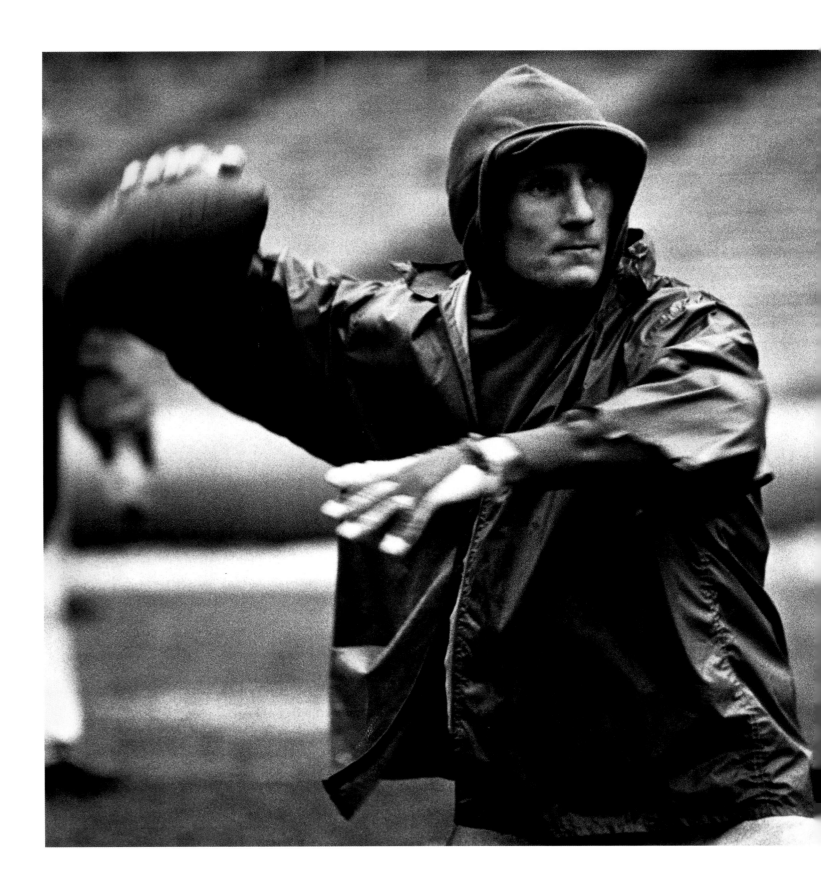

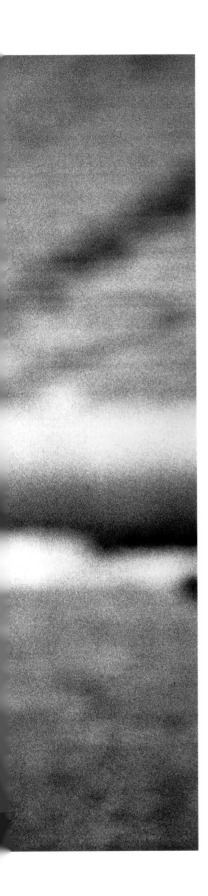

Giants' quarterback Y. A. Tittle during a practice drill. Yankee Stadium, 1963.

Cleveland's Jim Brown. Yankee Stadium, 1958.

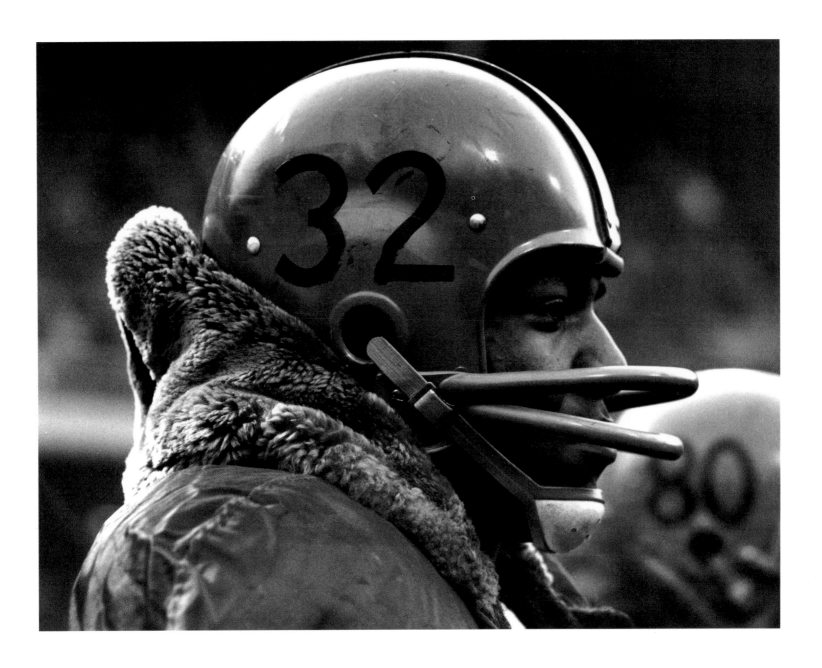

Don Chandler kicks for the New York Giants. Yankee Stadium, 1962.

Lenny Moore, the Baltimore Colts' running
back, takes a short swing pass from Johnny Unitas
and runs thirty-six yards through six Giant
tackles. Memorial Stadium, Baltimore, 1959.

Following pages: "The Golden Arm." Baltimore
Colts' quarterback Johnny Unitas passing
against the New York Giants' defense.
Championship Game, Yankee Stadium, 1958.

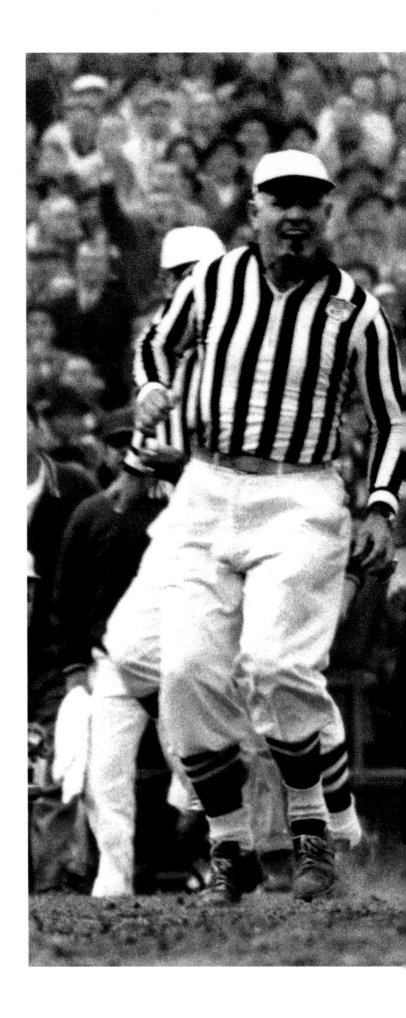

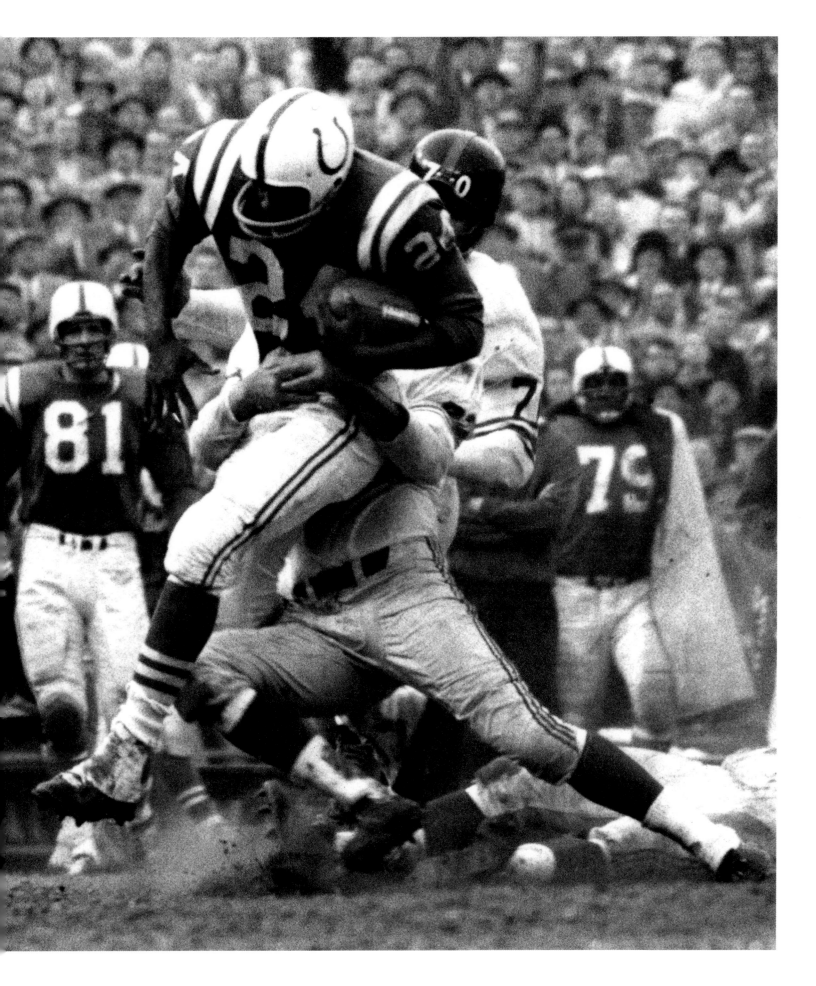

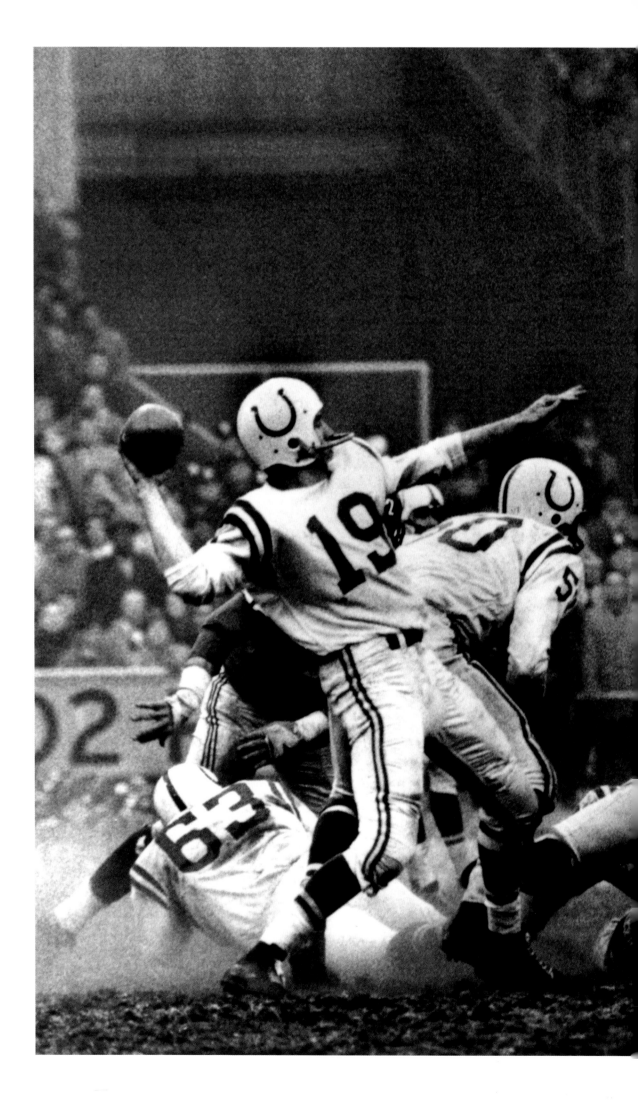

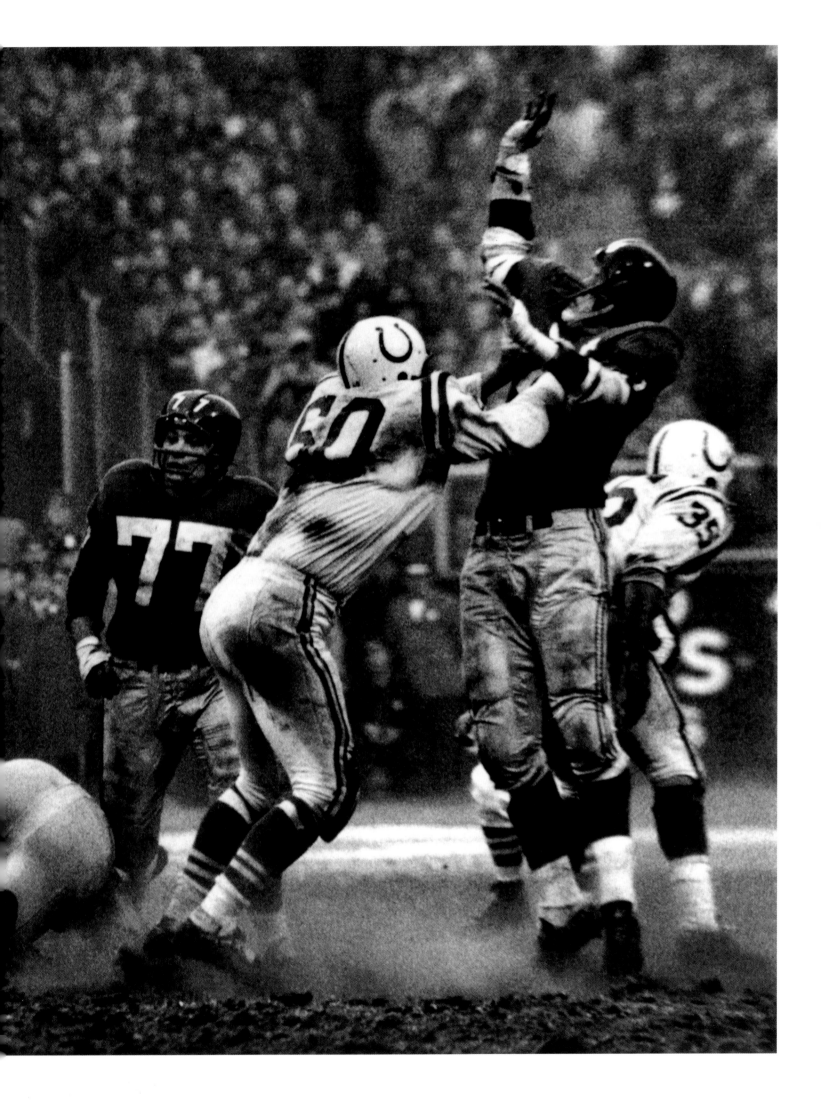

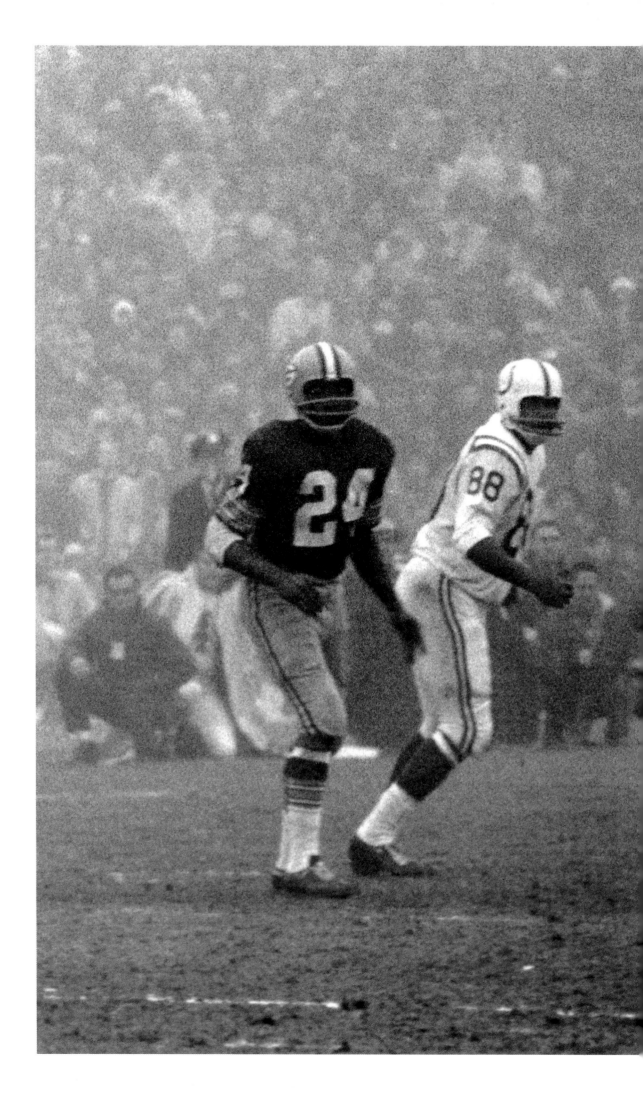

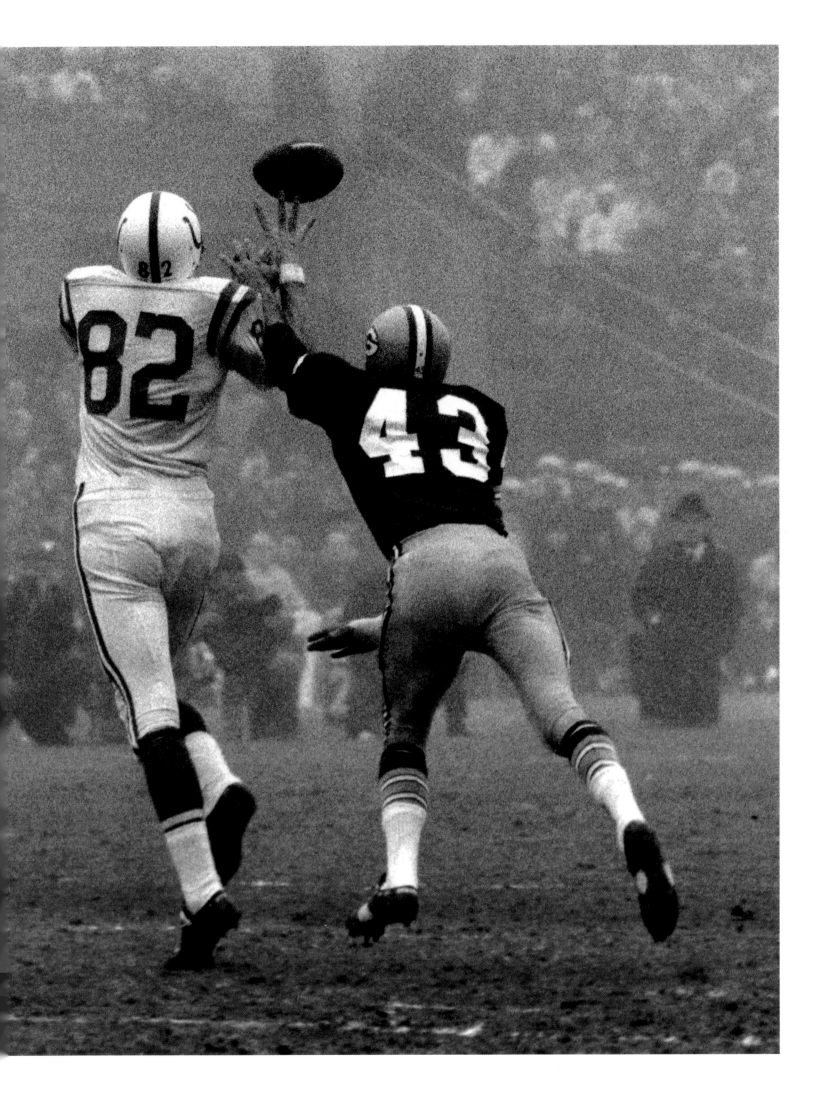

Otto Graham, Cleveland quarterback, 1953.

Preceding pages: Baltimore Colts' receiver Raymond Berry, number 82, splits Green Bay defenders. Wisconsin, 1961.

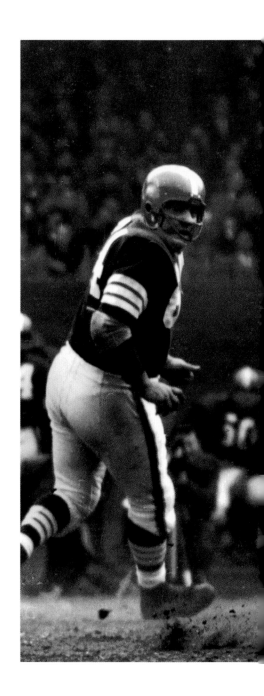

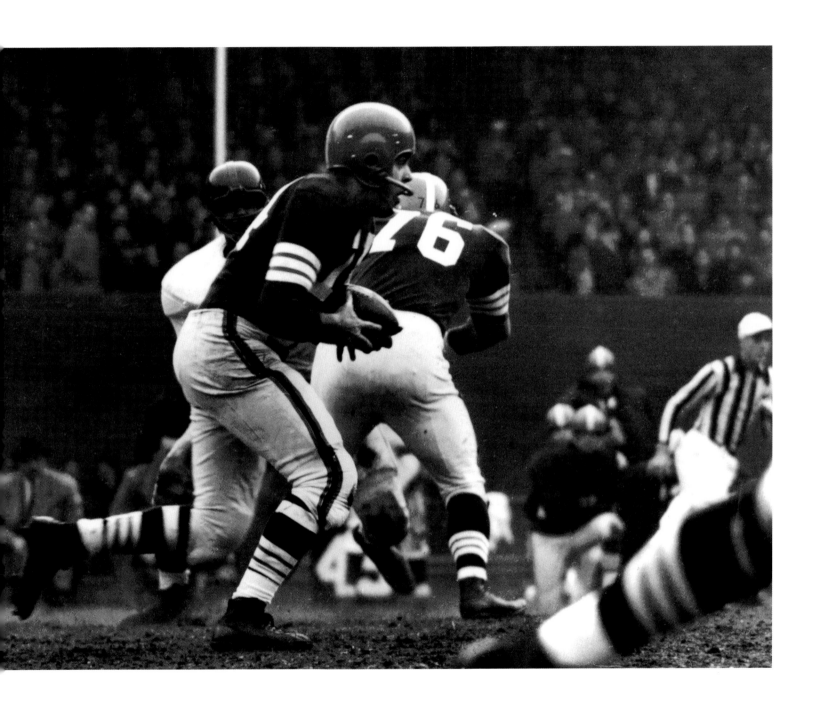

New York Giants' Frank Gifford, flanked on the bench by Kyle Rote and Charlie Conerly. Yankee Stadium, 1959.

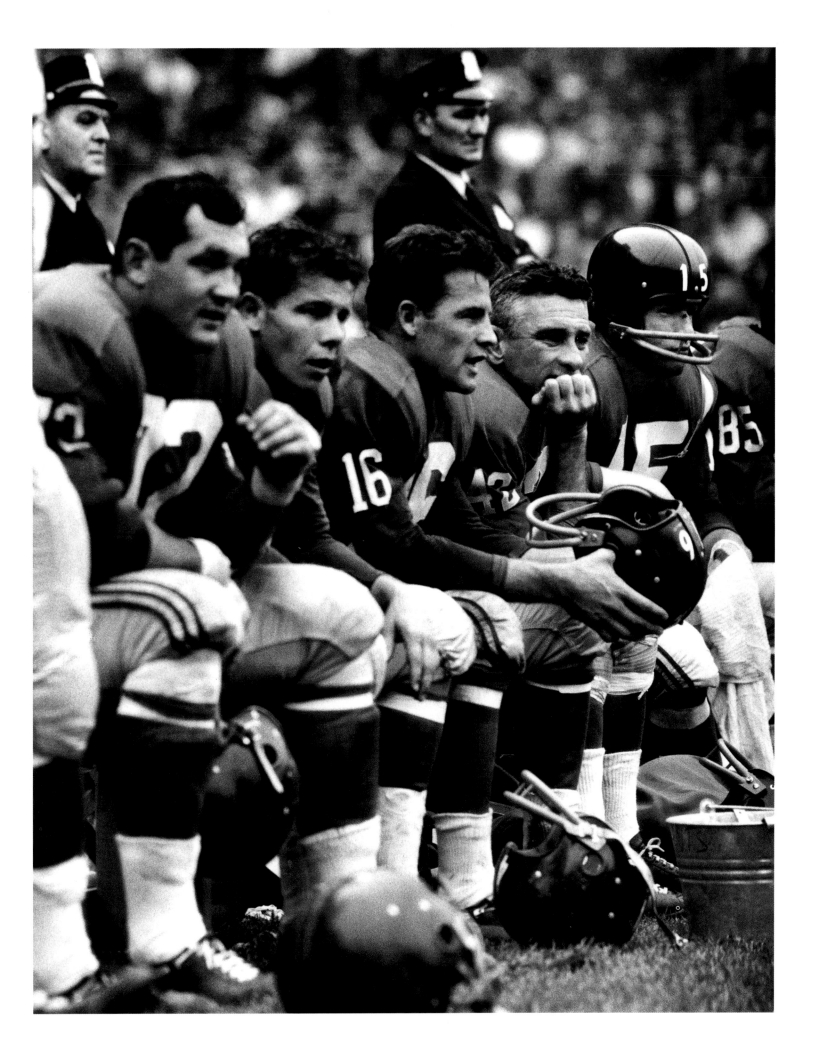

New York Giants' tackle Roosevelt Brown in his rookie year, seated next to Gene Filipski and Don Chandler, 1956.

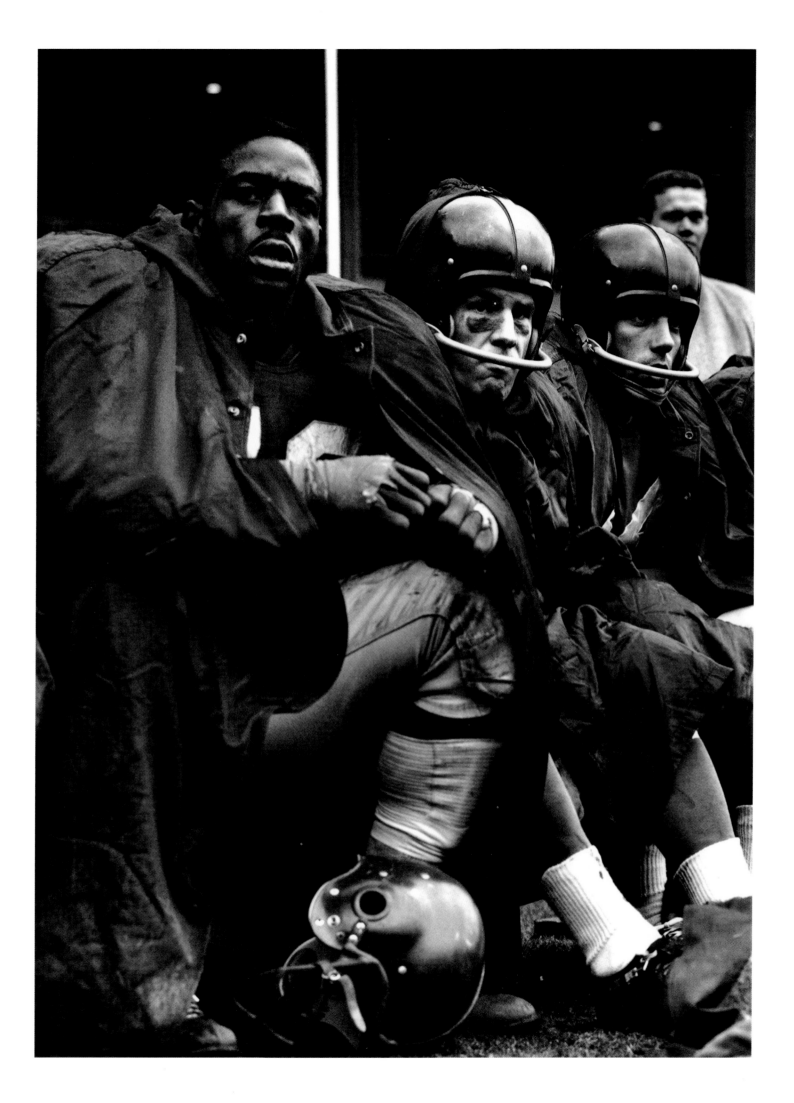

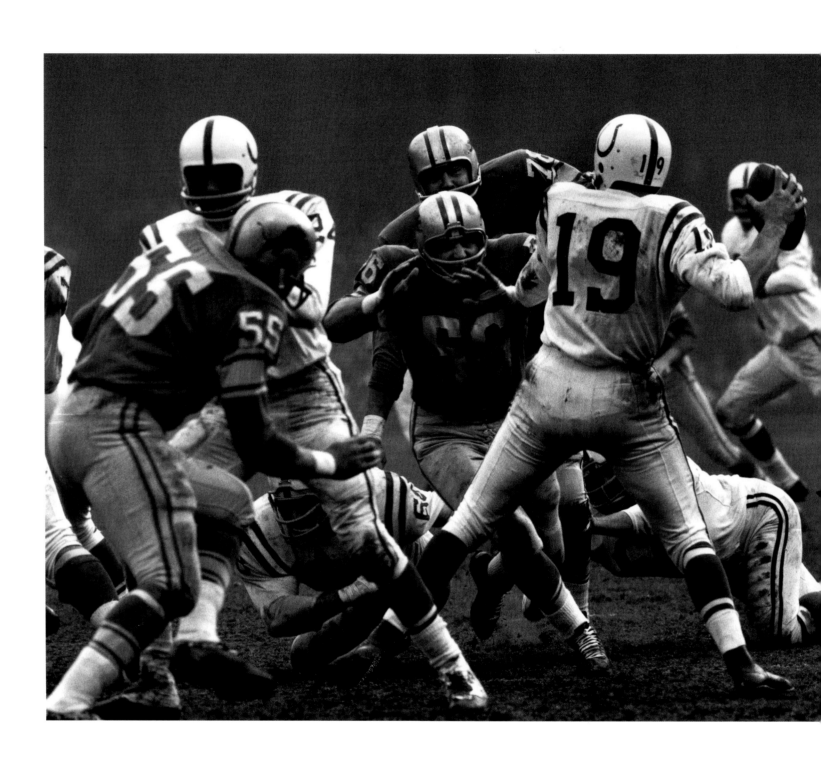

Detroit Lions' linebacker Joe Schmidt, number 56, charges Johnny Unitas. Detroit, 1962.

"Over the Top." Redskin Johnny Olszewski scores against the Giants. Yankee Stadium, 1960.

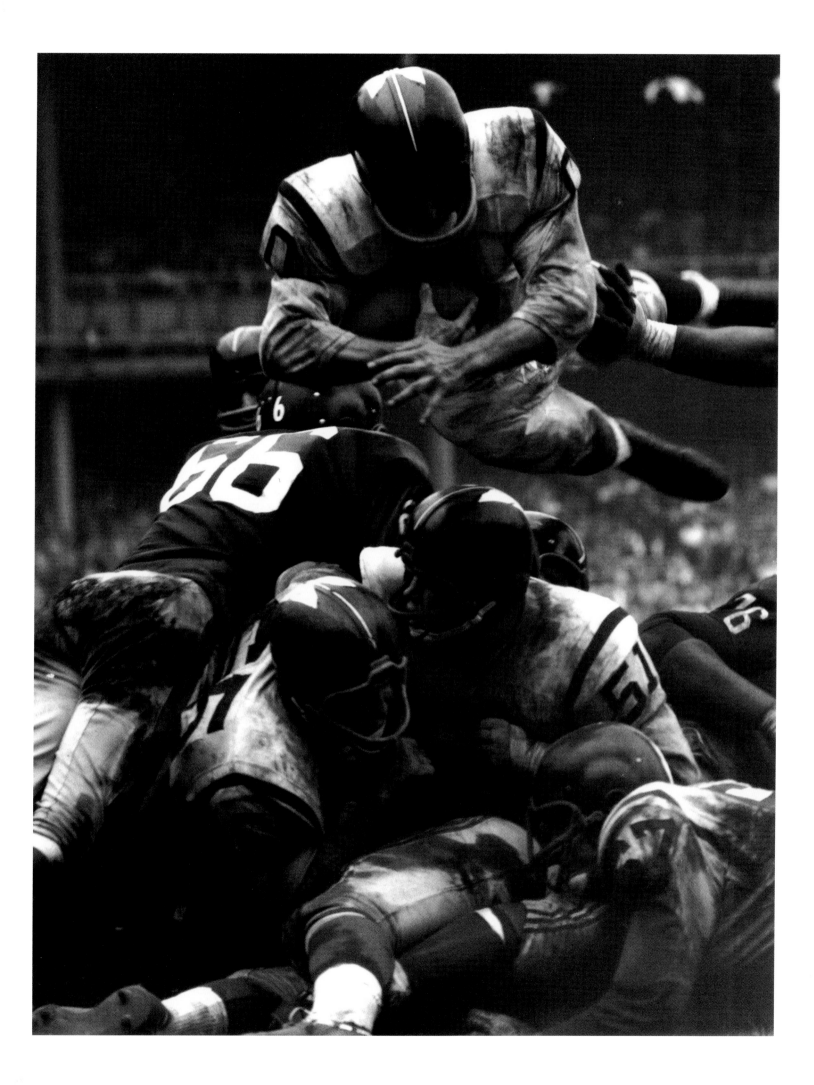

Cleveland running back Jim Brown is brought down by several Giants. Yankee Stadium, 1959.

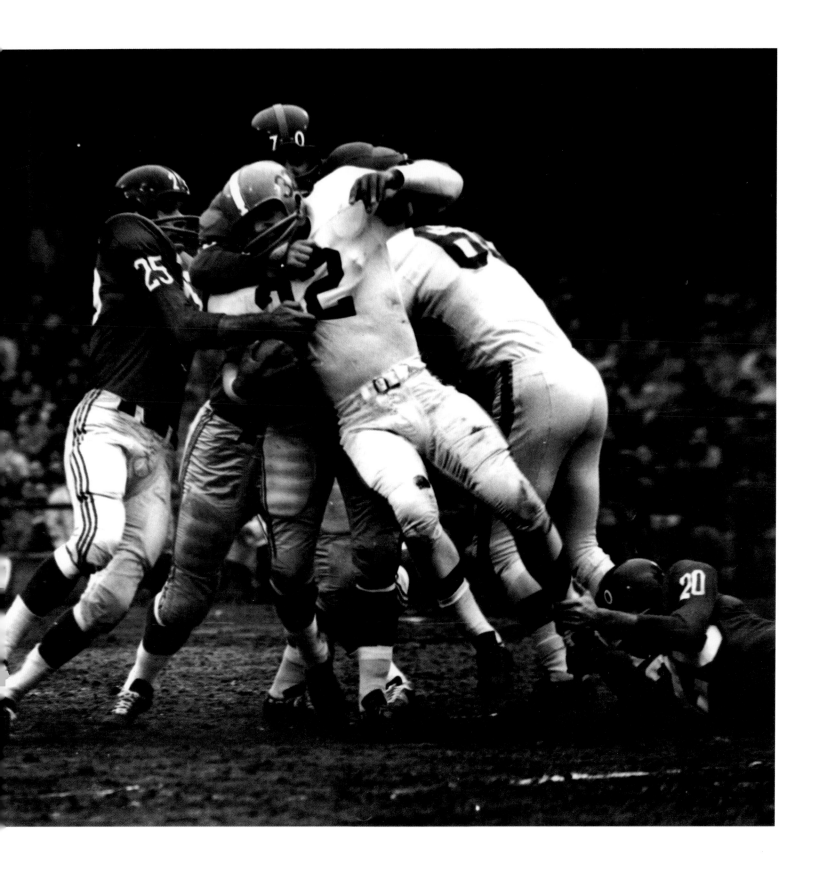

Frank Gifford and Vince Lombardi, the Giants' assistant coach, in the mud at Yankee Stadium, 1956.

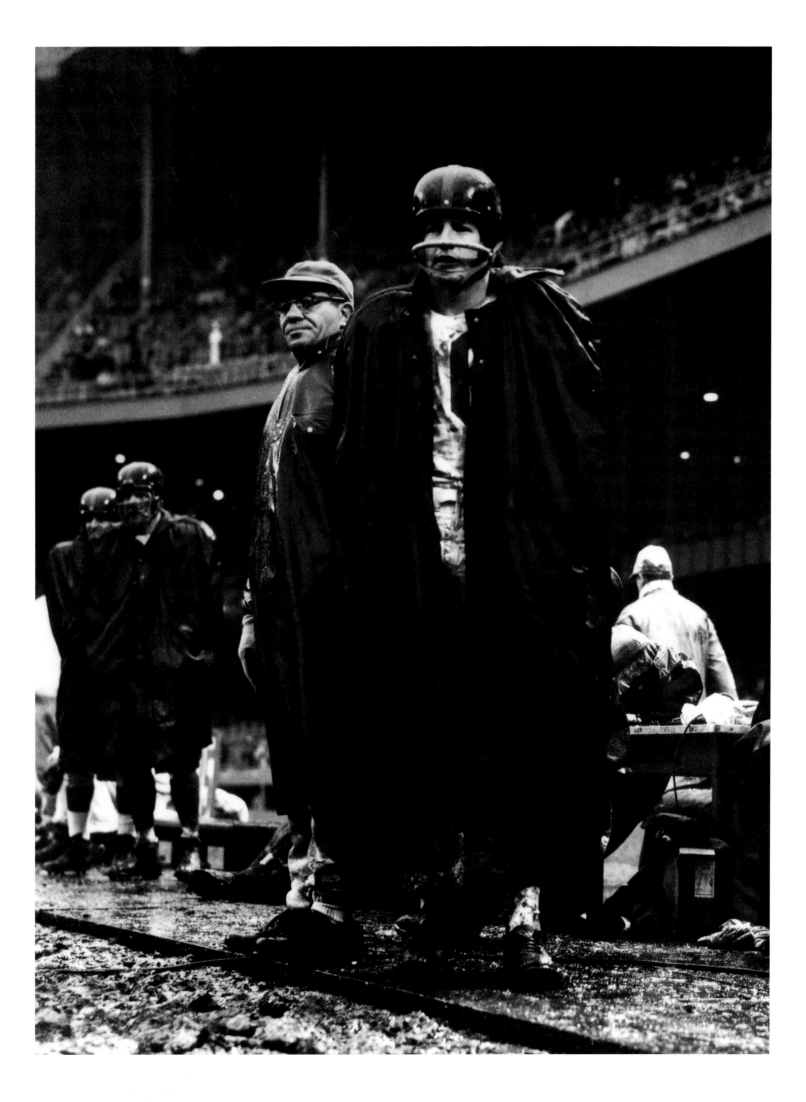

"The Mudhead." Green Bay Packers' tackle Forrest Gregg. Kezar Stadium, San Francisco, 1960.

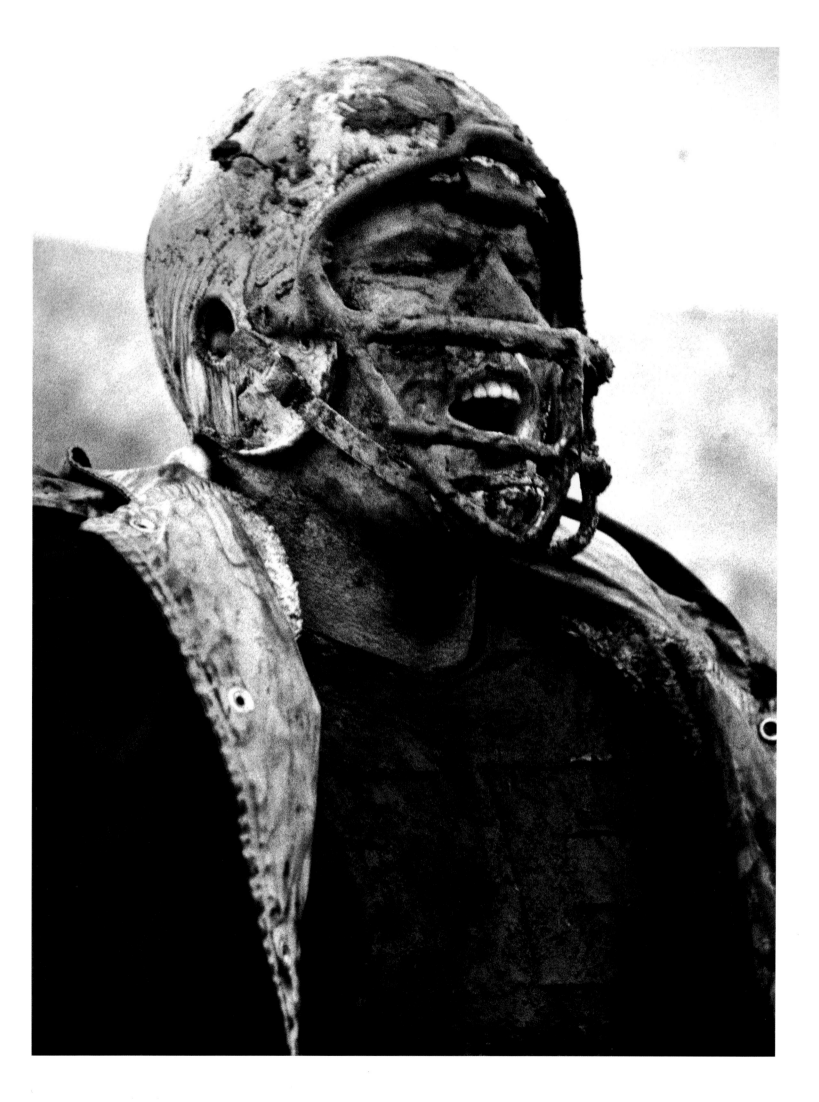

Ray Nitschke and Green Bay teammates on bench in the mud. Kezar Stadium, San Francisco, 1960.

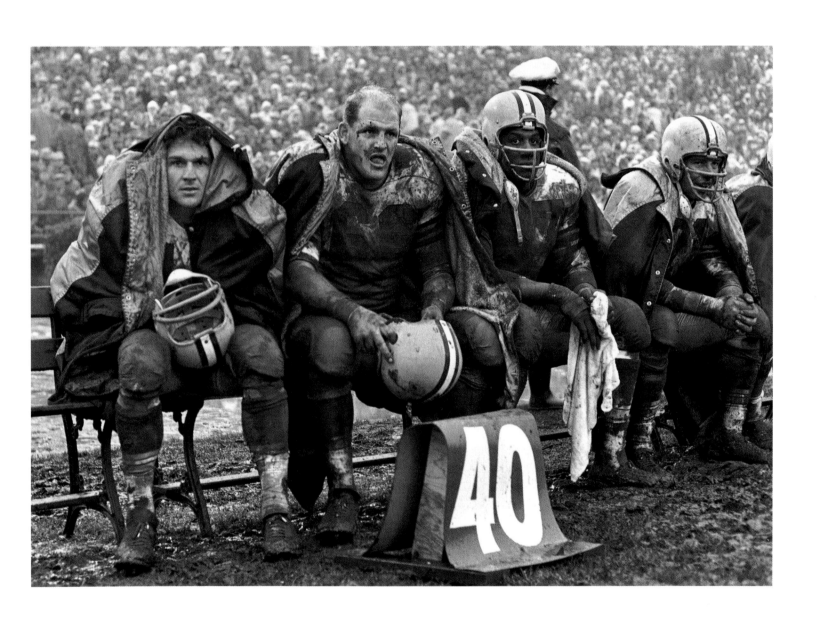

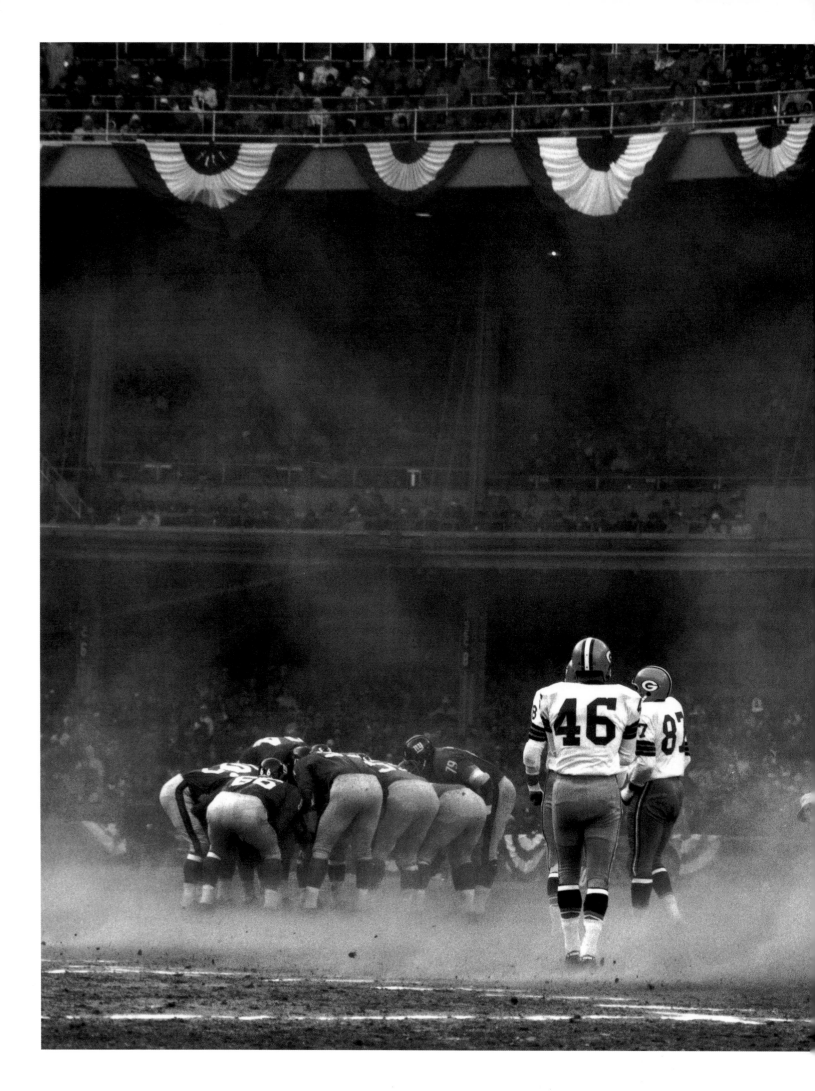

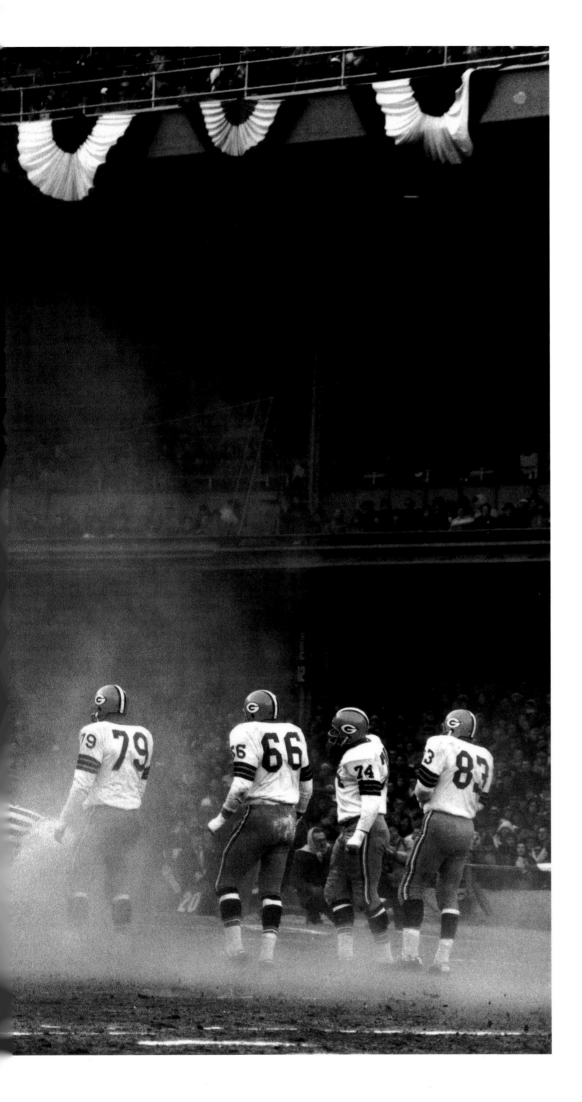

"The Lombardi Trap." Green Bay running back Jim Taylor
scores against the Cleveland Browns. Municipal Stadium, Cleveland, 1961.

Preceding pages: Green Bay vs. the Giants, Championship Game, Yankee Stadium, 1962.

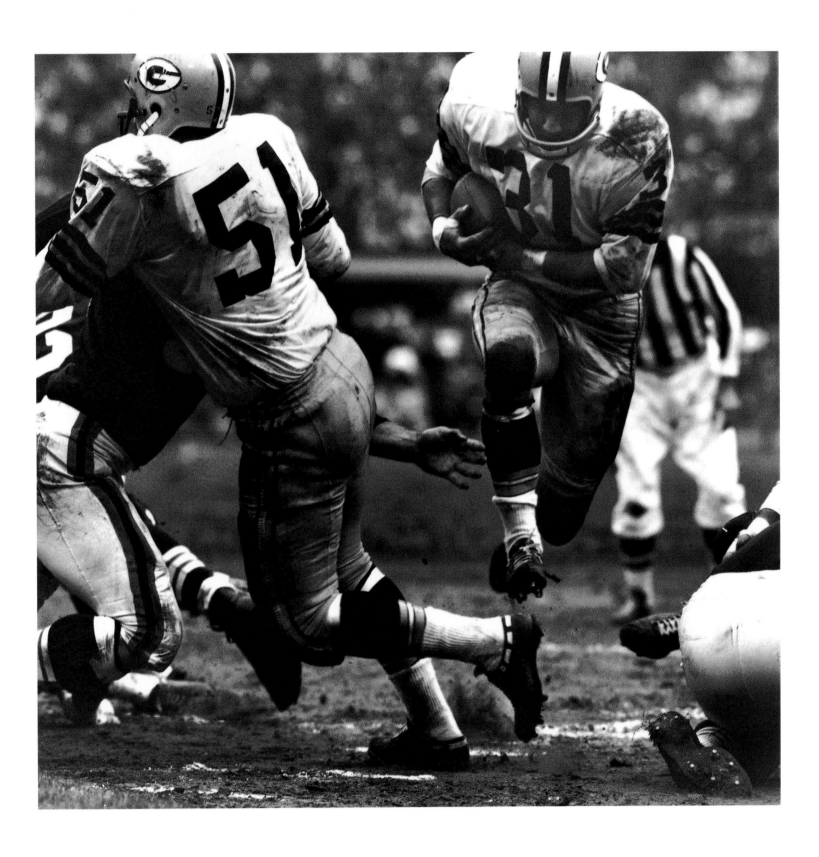

Los Angeles Rams' Jack Youngblood.

Following pages: Cleveland running back Jim Brown outruns Giant defense. Yankee Stadium, New York, 1958.

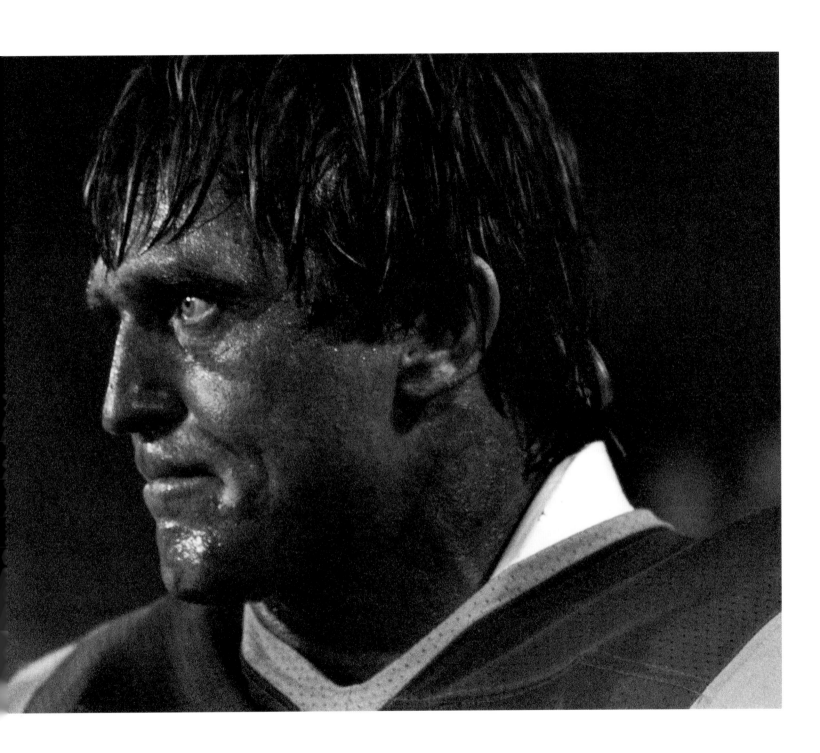

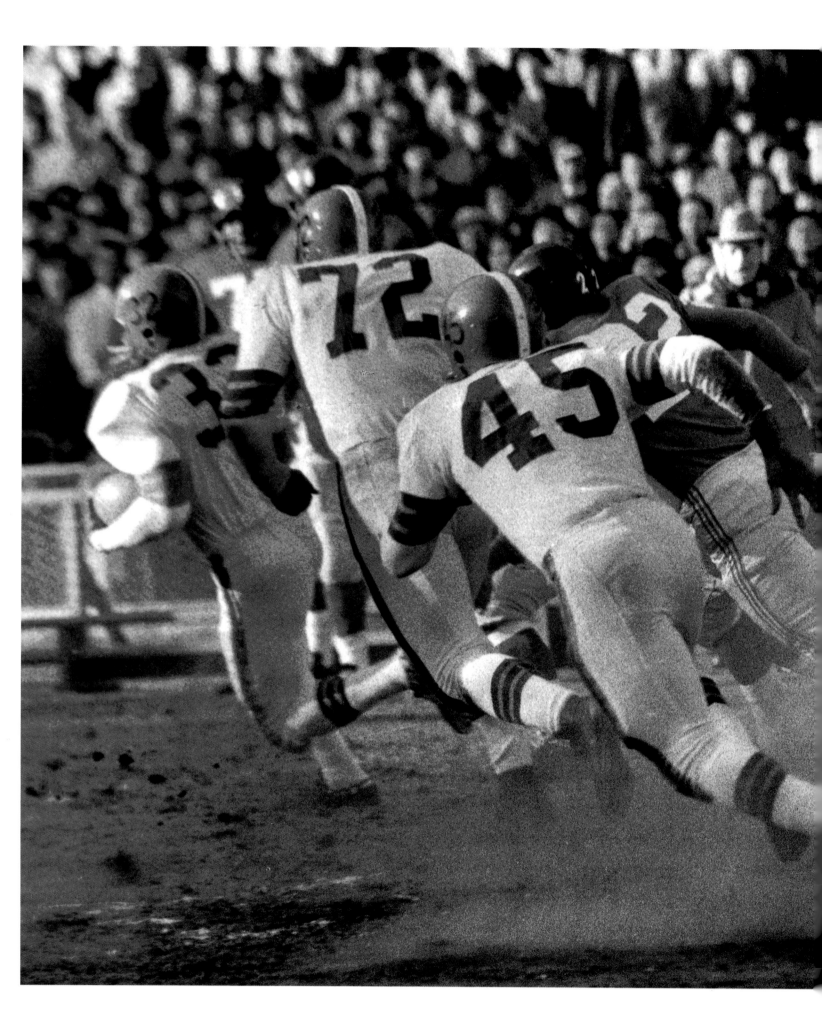

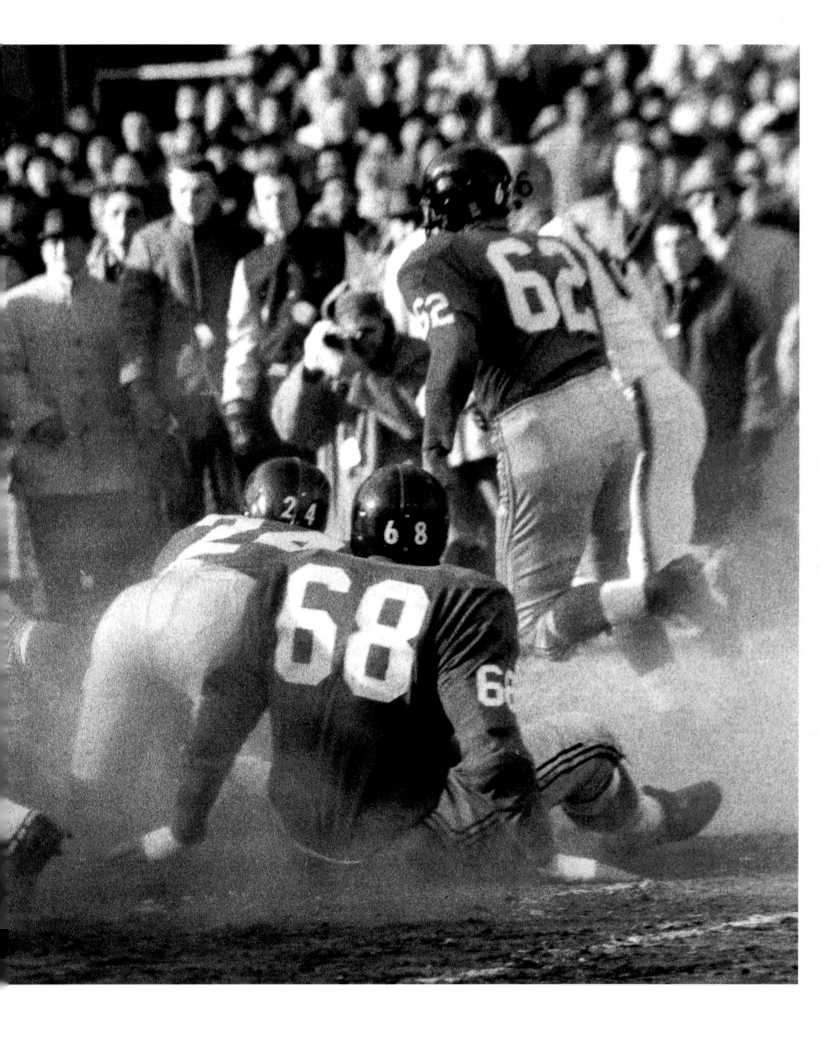

Green Bay linebacker Bill Forrester stops a long run. Detroit, 1961.

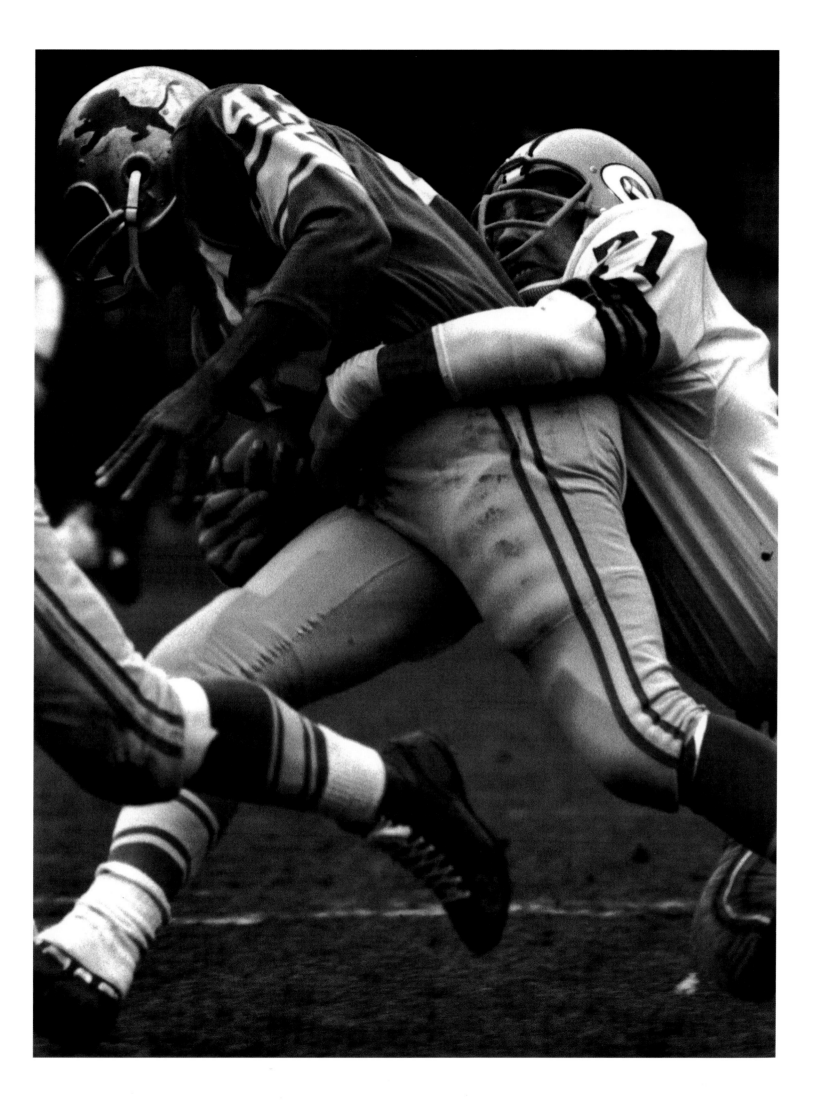

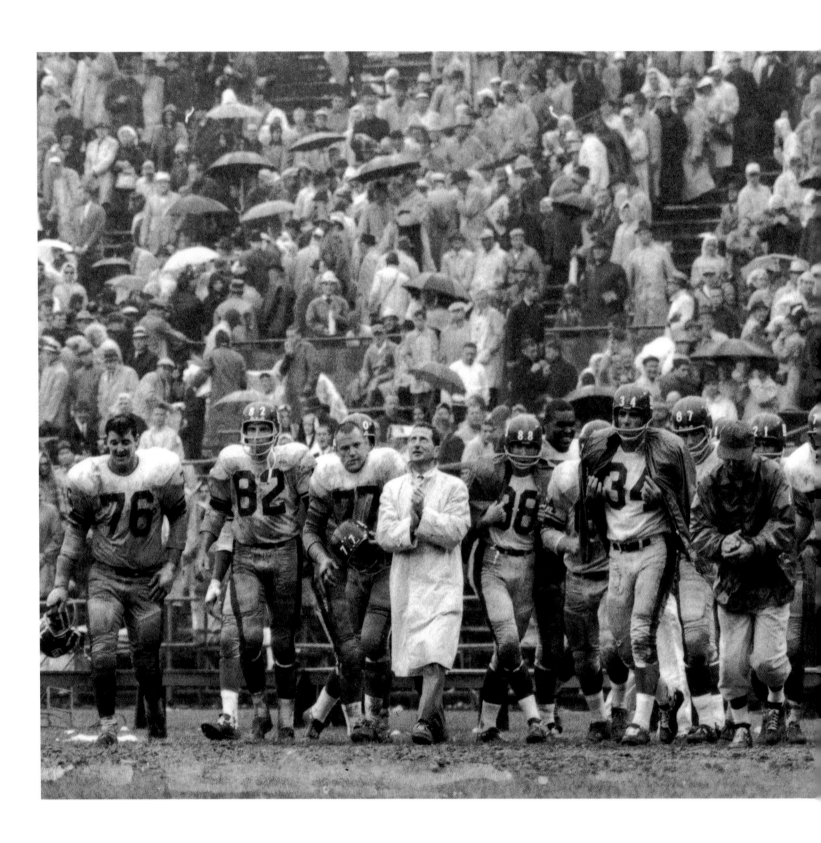

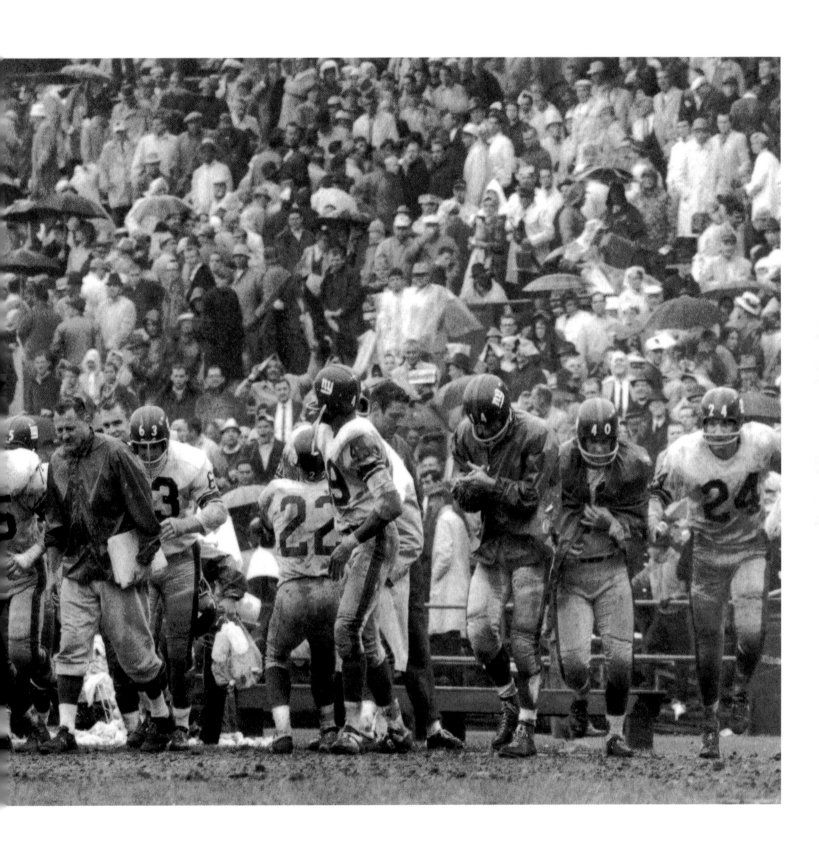

Bill Pellington, linebacker, Baltimore Colts.

Preceding pages: New York Giants' coach Allie Sherman leads his team across the field. Baltimore, 1963.

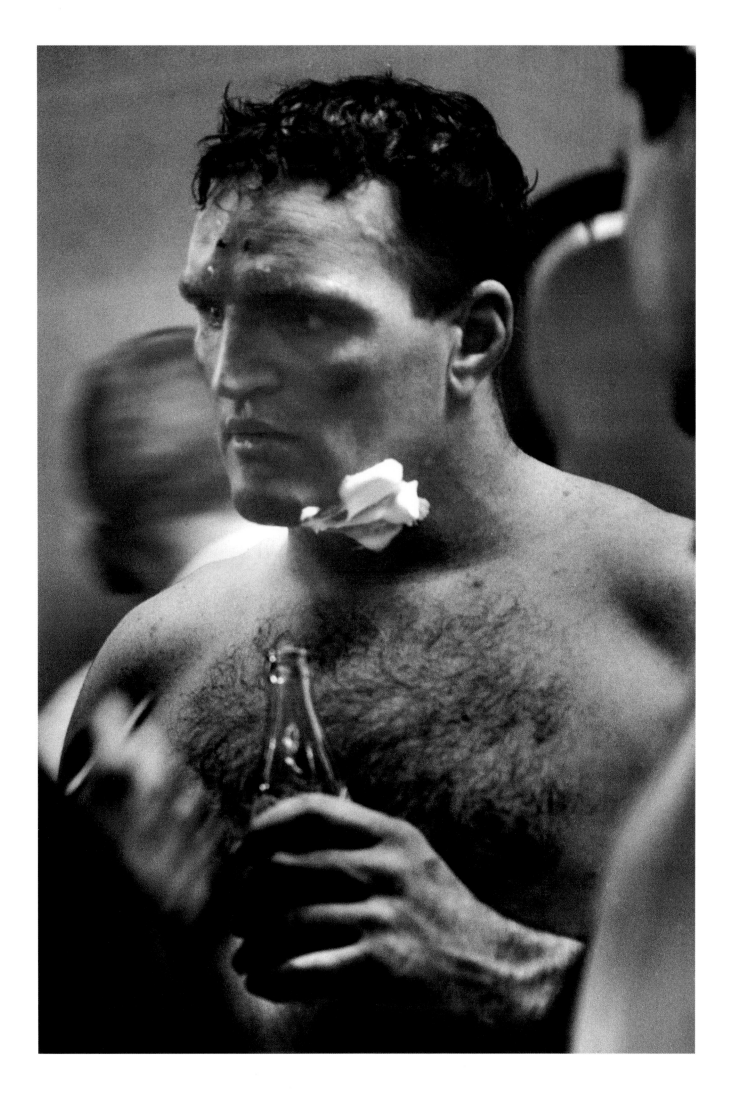

Heavyweight champion Cassius Clay (Muhammad Ali) training for his fight with Sonny Liston. Lewiston, Maine, 1965.

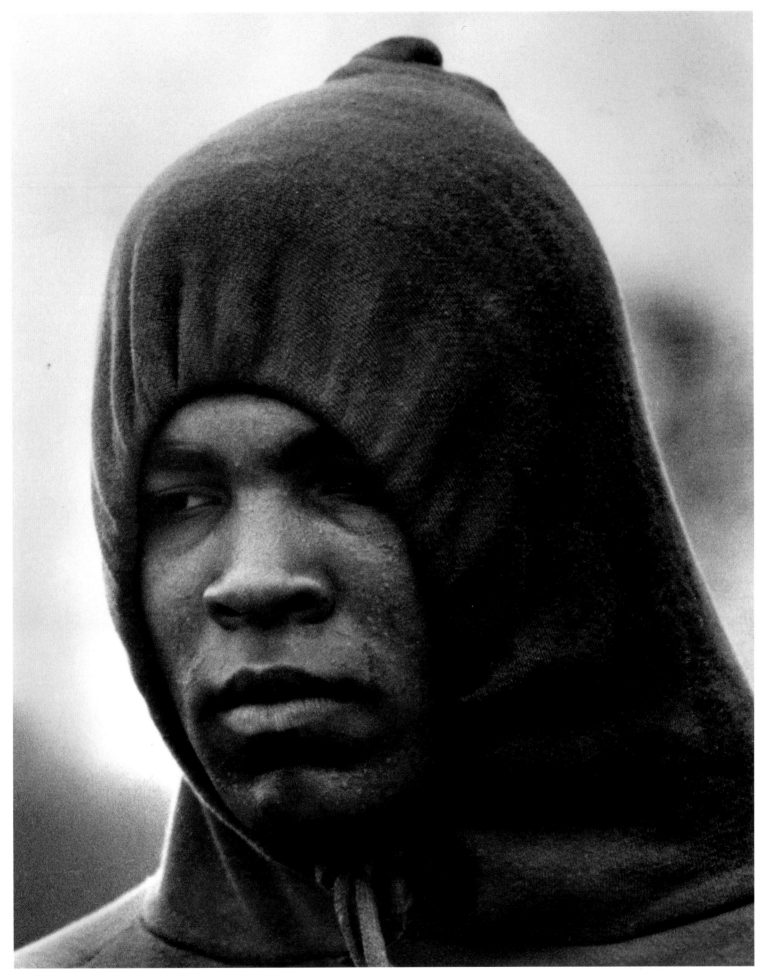

Muhammad Ali and Joe Frazier, 1971.

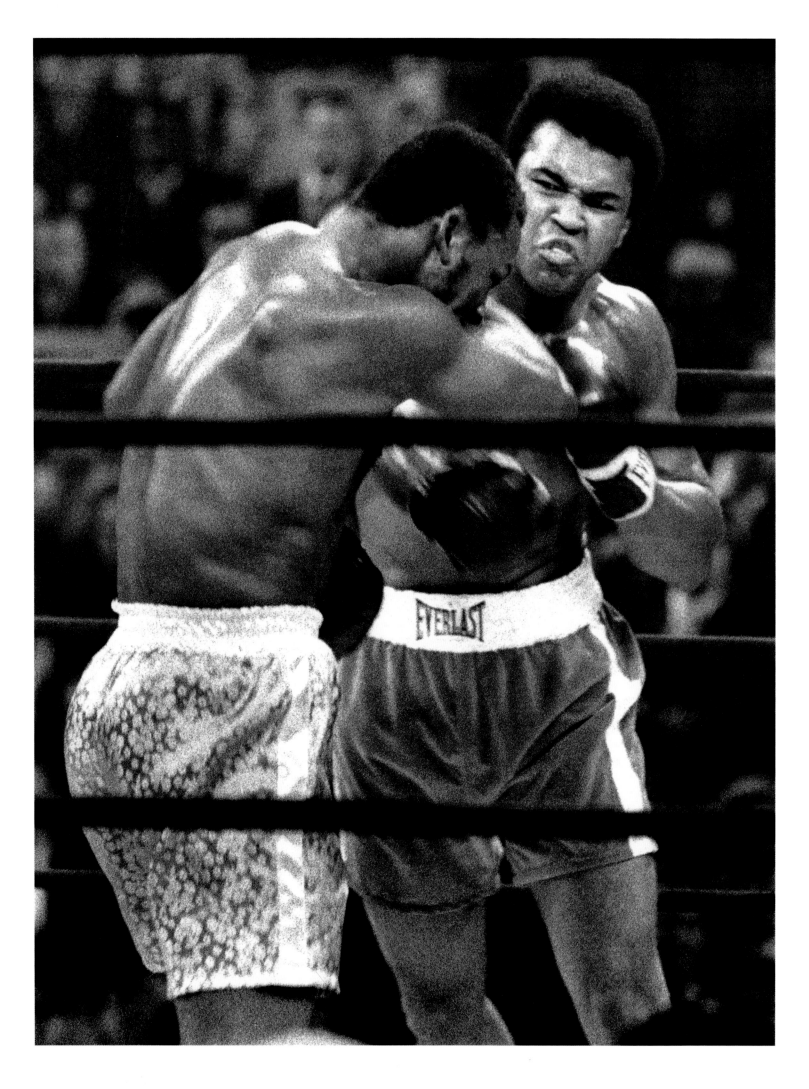

Sonny Liston knocks out Floyd Patterson. Comiskey Park, Chicago, 1962.

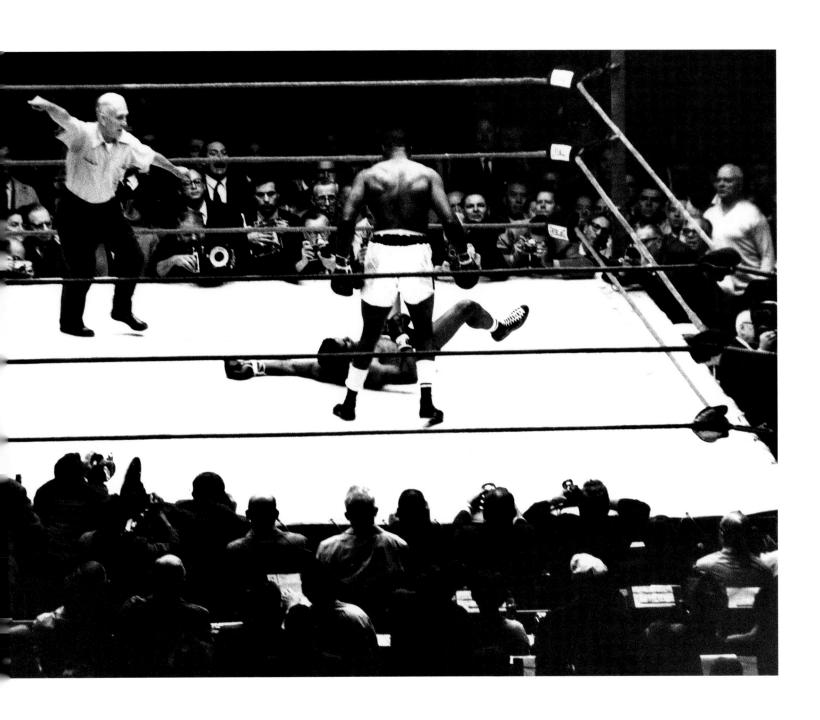

Olympic Games, Barcelona, 1992.

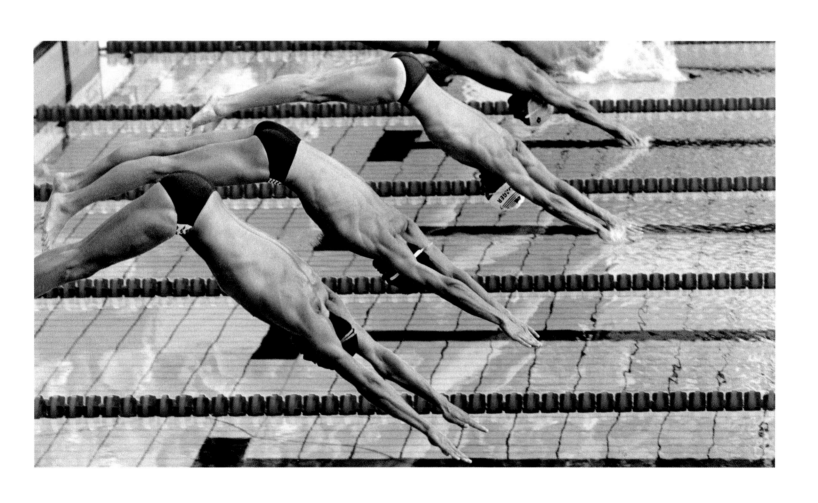

Greg Louganis.

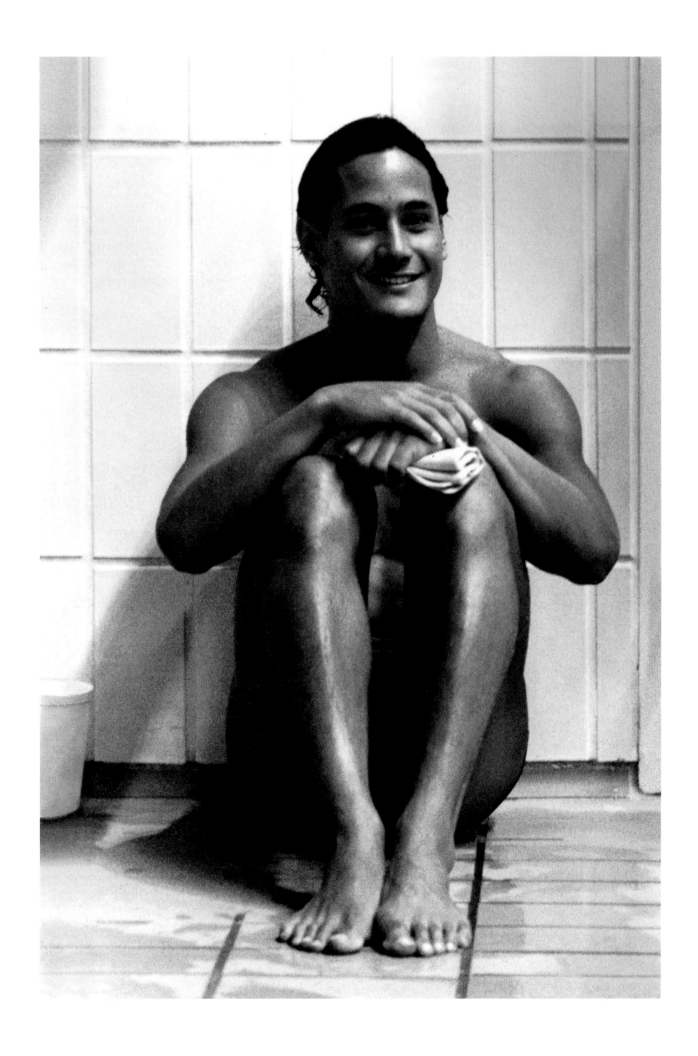

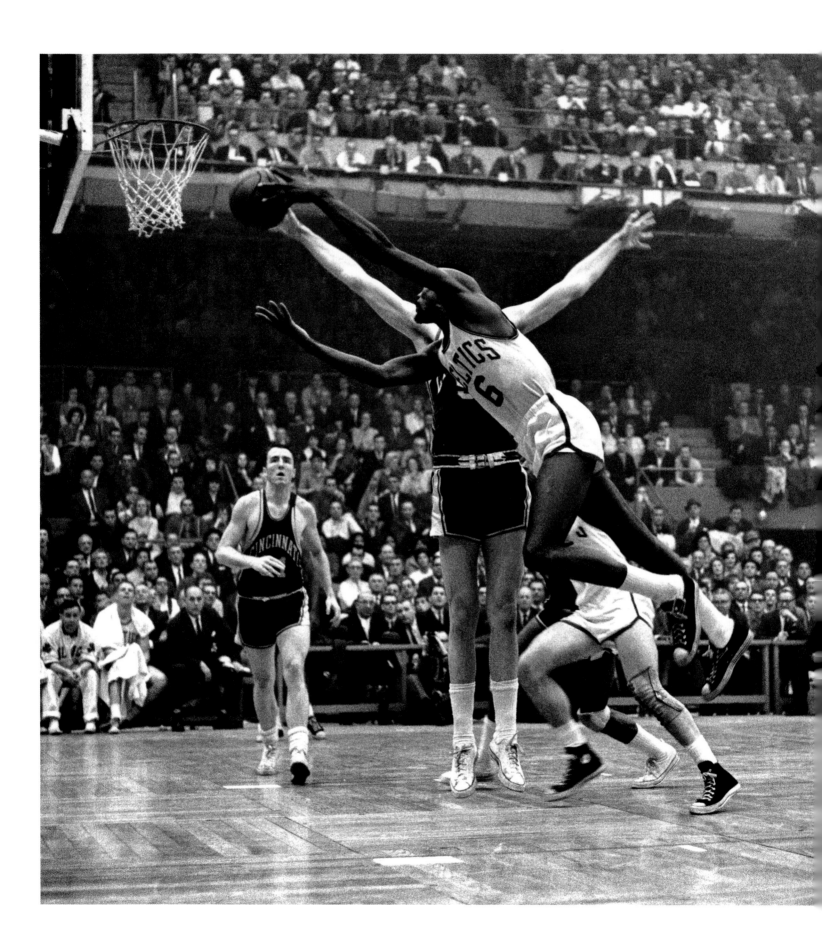

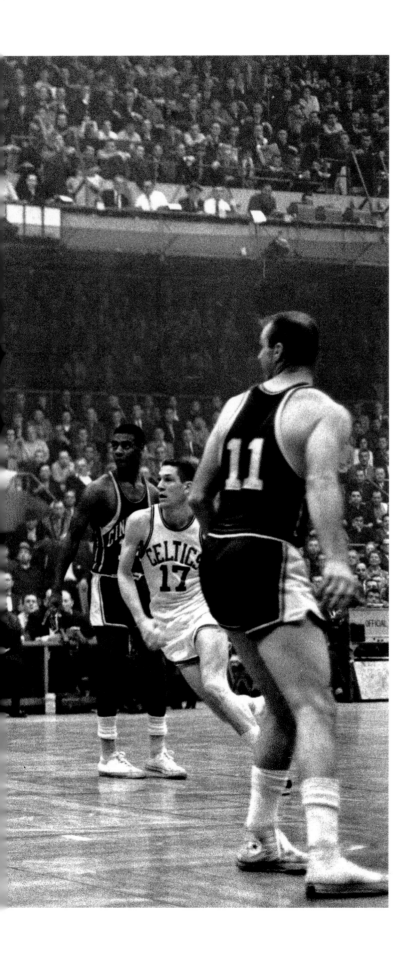

Celtic Bill Russell slips past Cincinnati
to score. Boston Garden, 1964.

Michael Jordan, Chicago Bulls guard. Los Angeles, 1990.

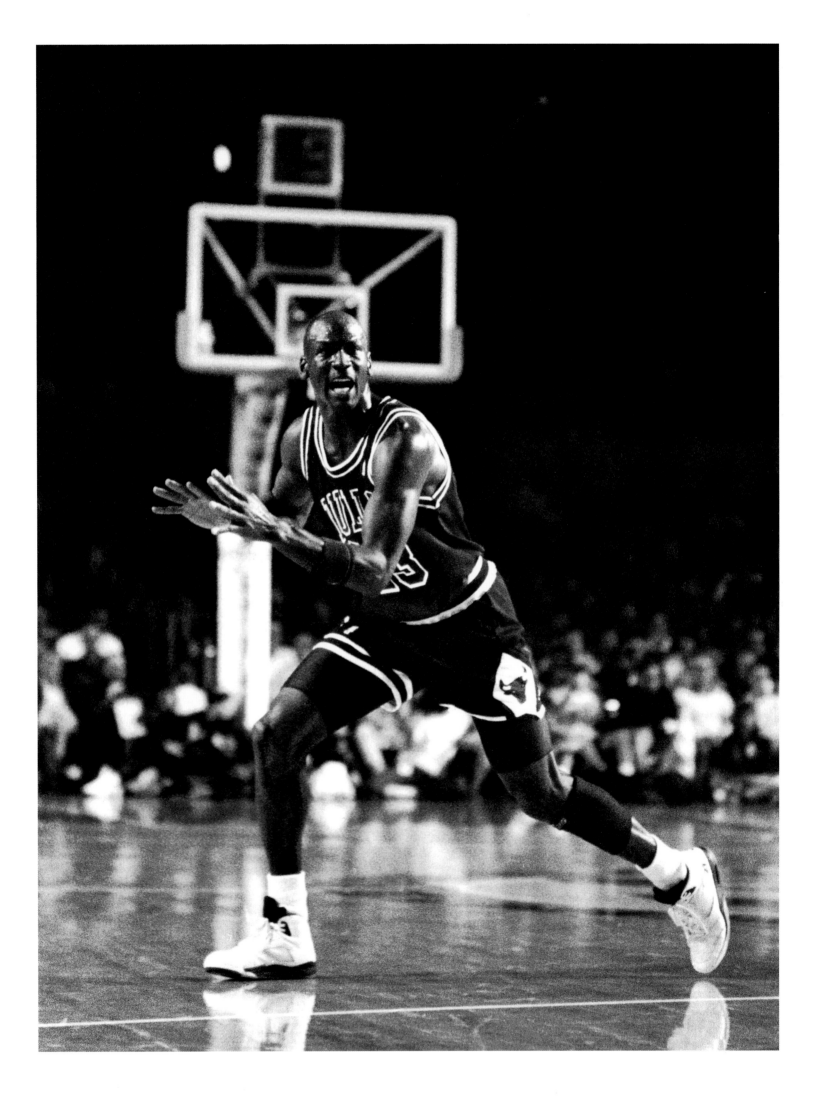

Philadelphia's Wilt Chamberlain covers the ball at Boston Garden during a game with the Celtics, 1959.

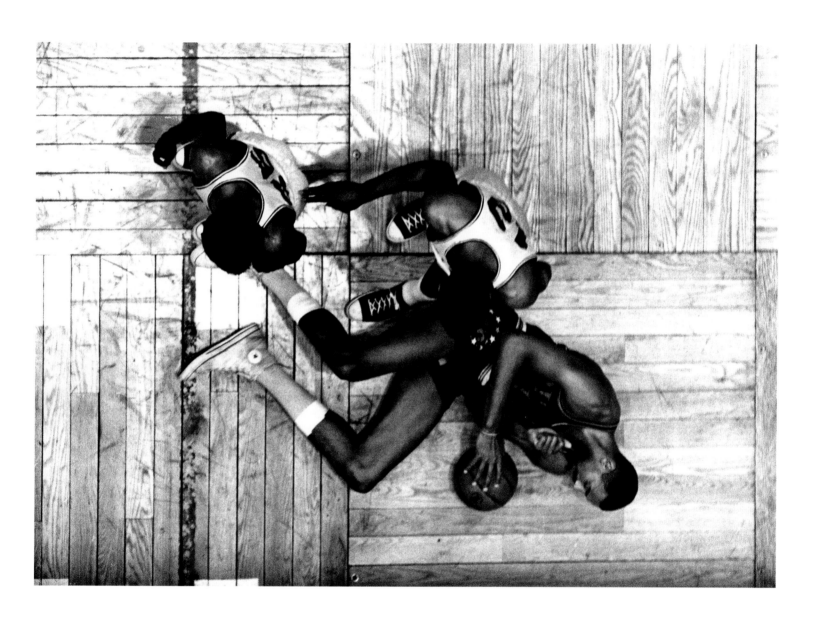

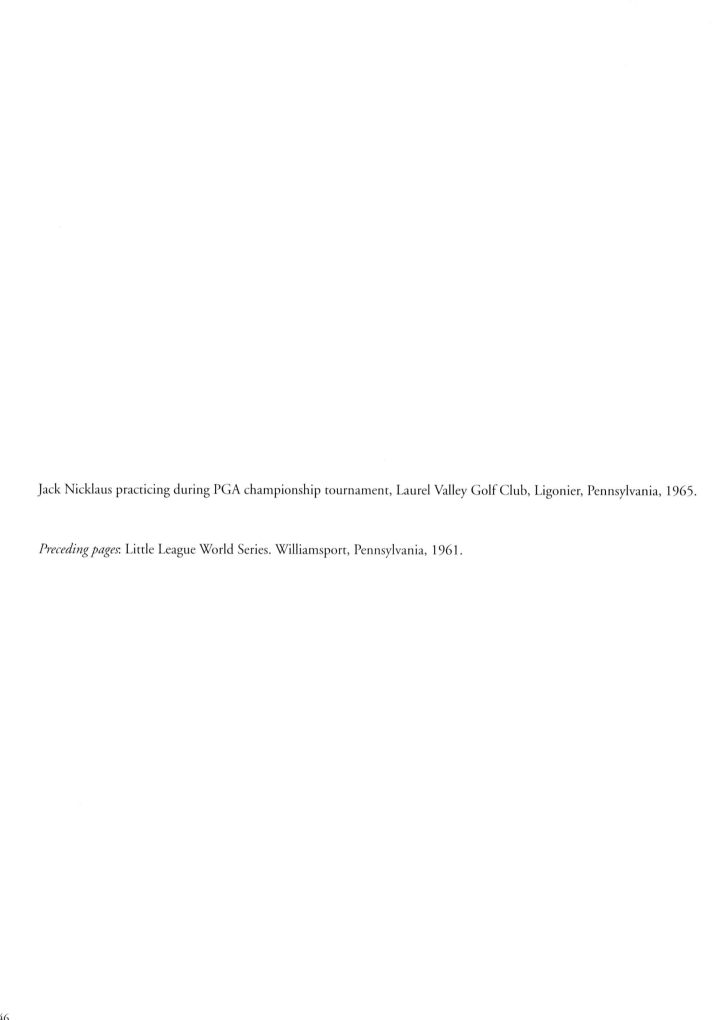

Jack Nicklaus practicing during PGA championship tournament, Laurel Valley Golf Club, Ligonier, Pennsylvania, 1965.

Preceding pages: Little League World Series. Williamsport, Pennsylvania, 1961.

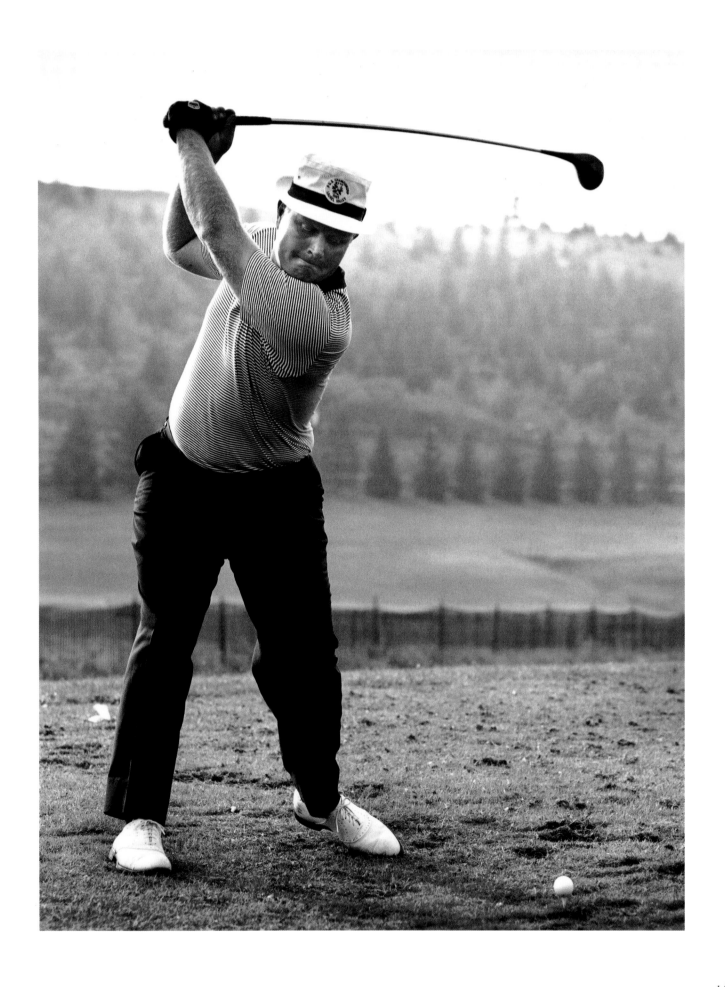

Bjorn Borg, 1979.

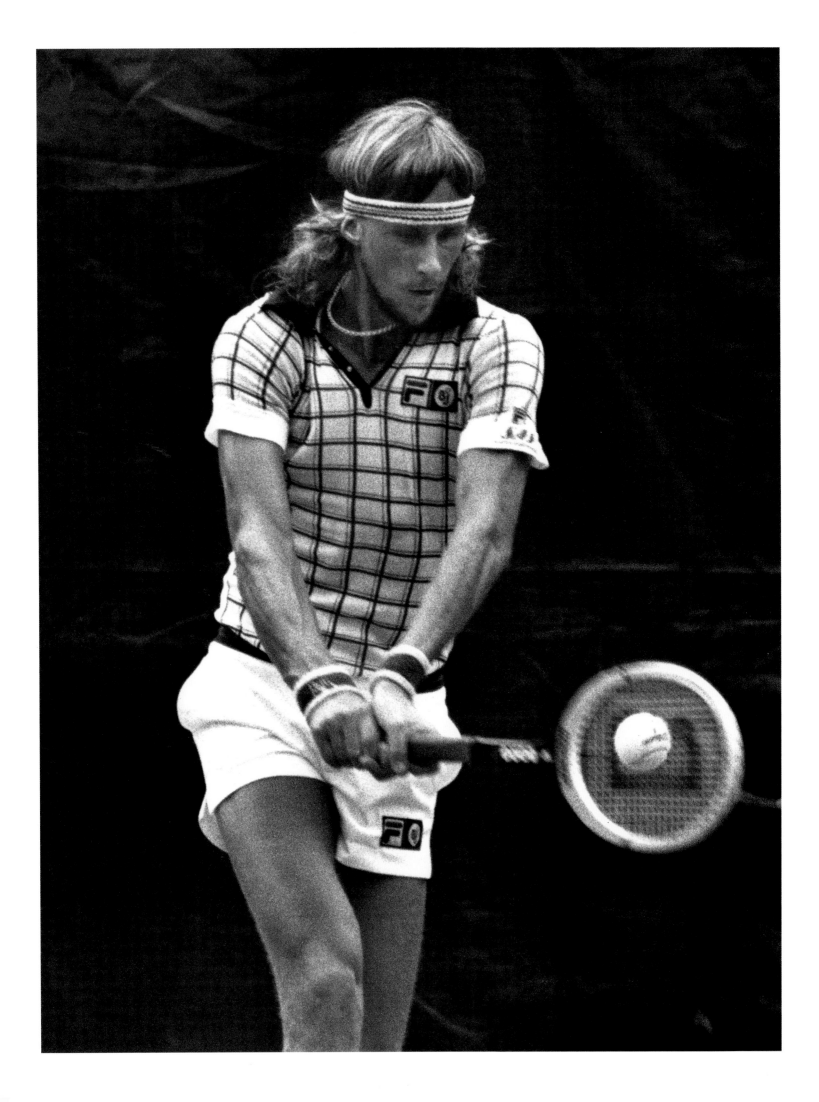

Jimmy Connors, 1991.

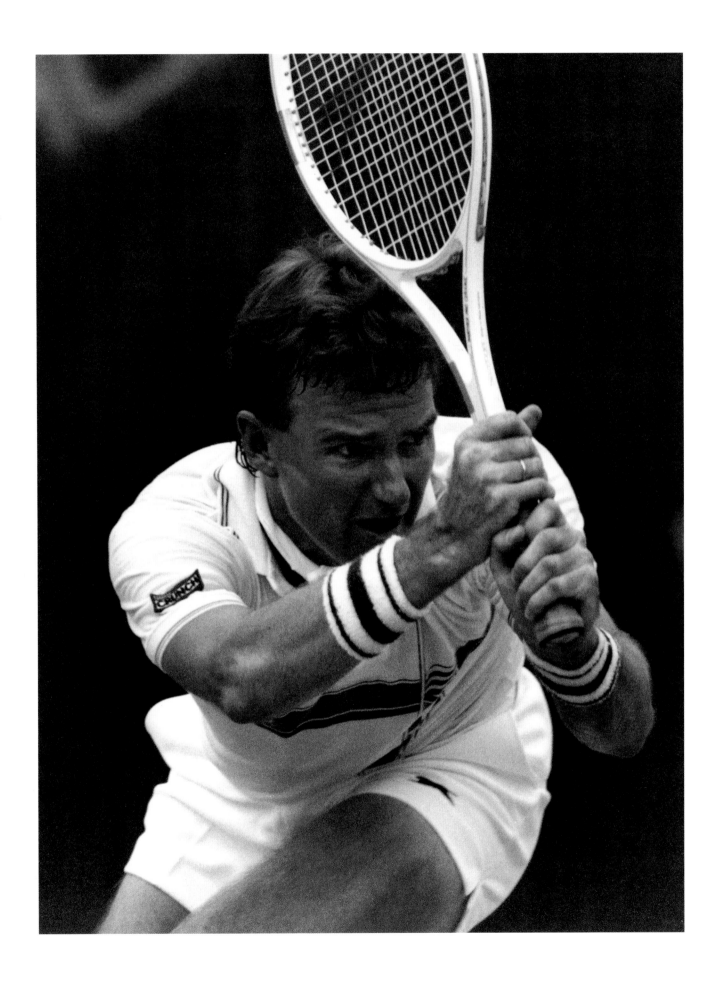

Billie Jean King, 1978.

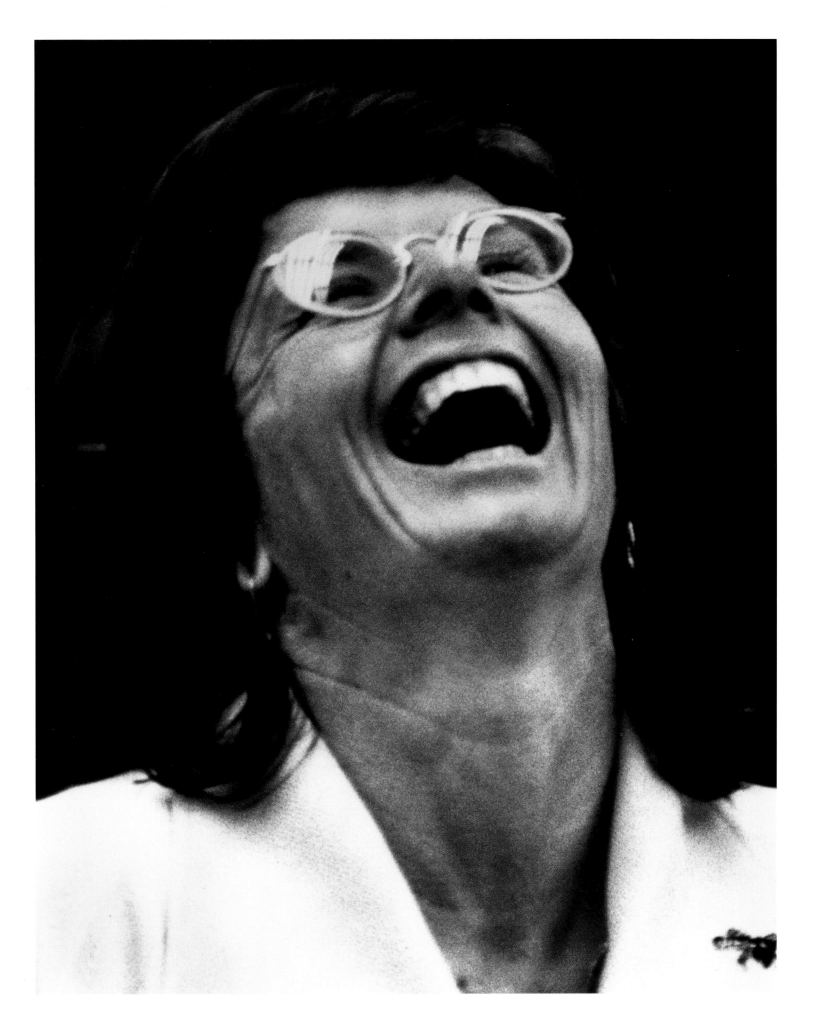

Tour de France, 1990.

Following pages: Wilma Rudolph, 400-meter relay. Olympic Games, Rome, 1960.

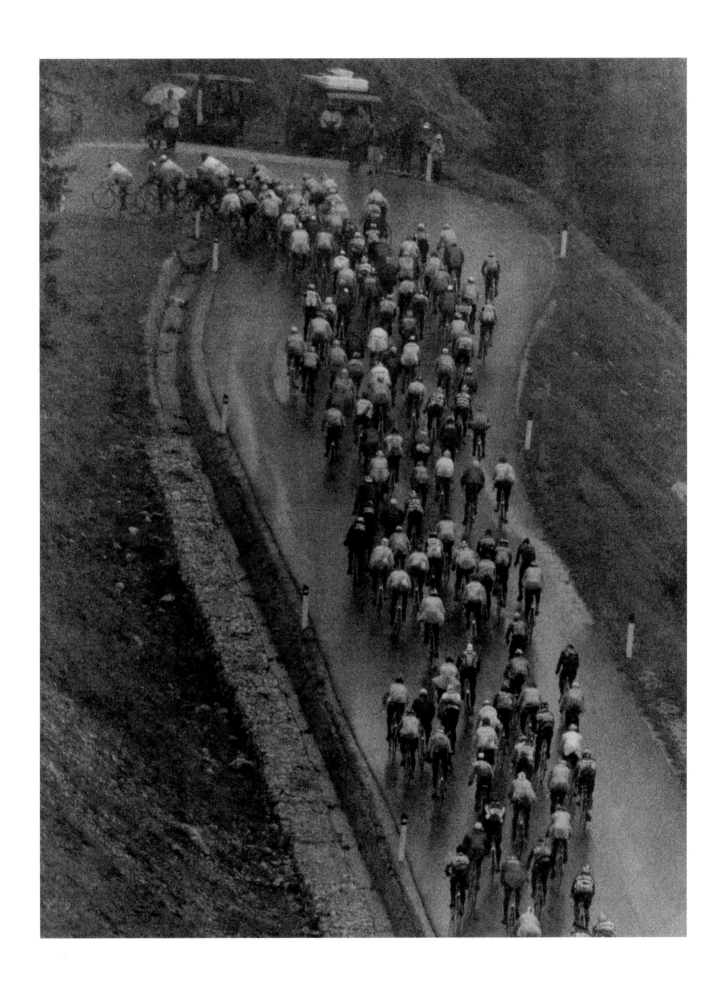

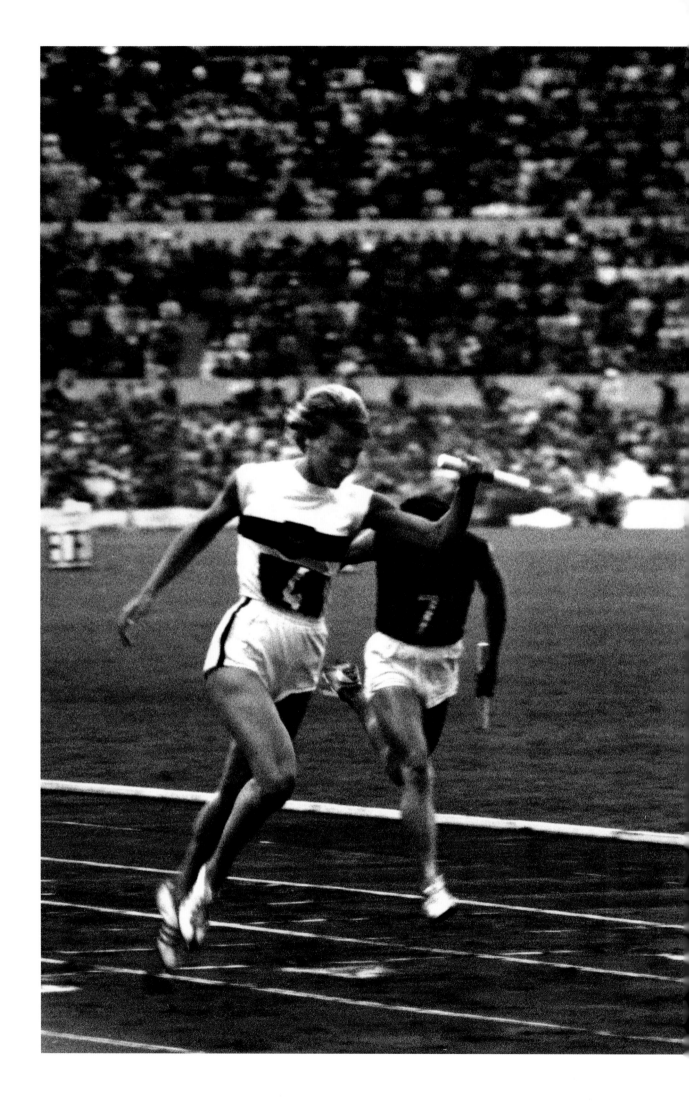

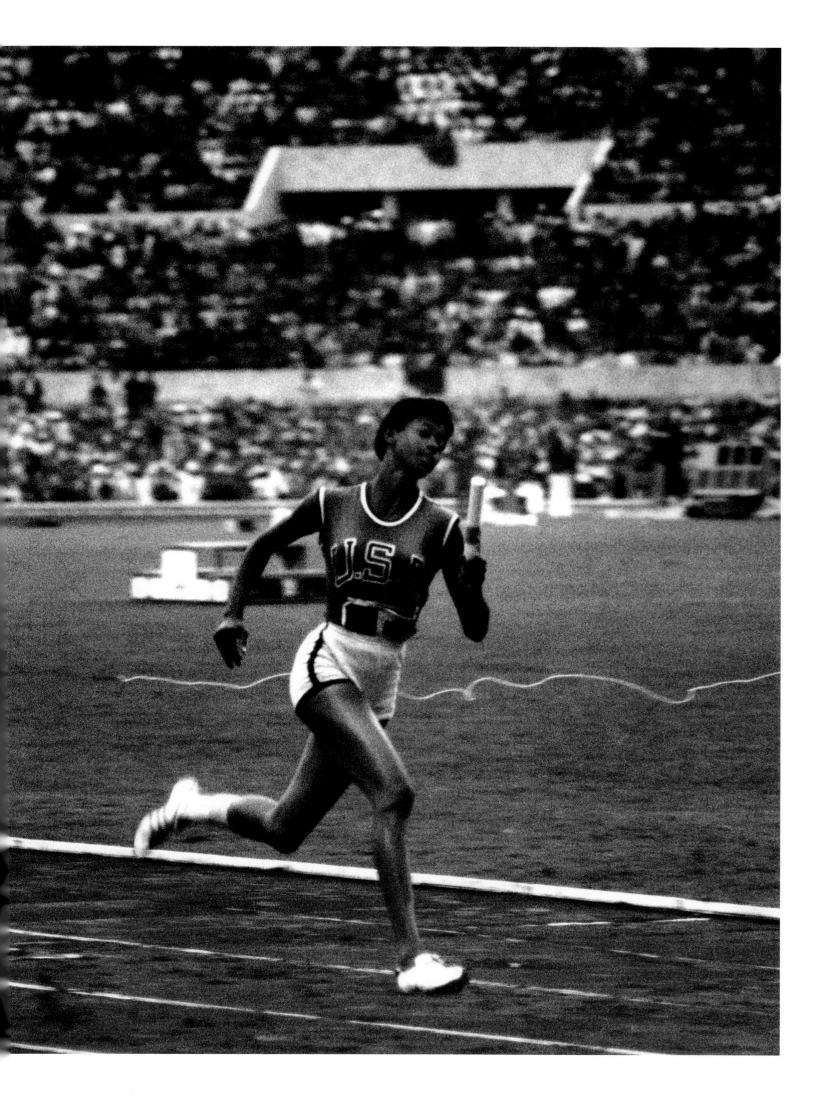

Nadia Comaneci on the balance beam at Madison Square Garden, New York, 1977.

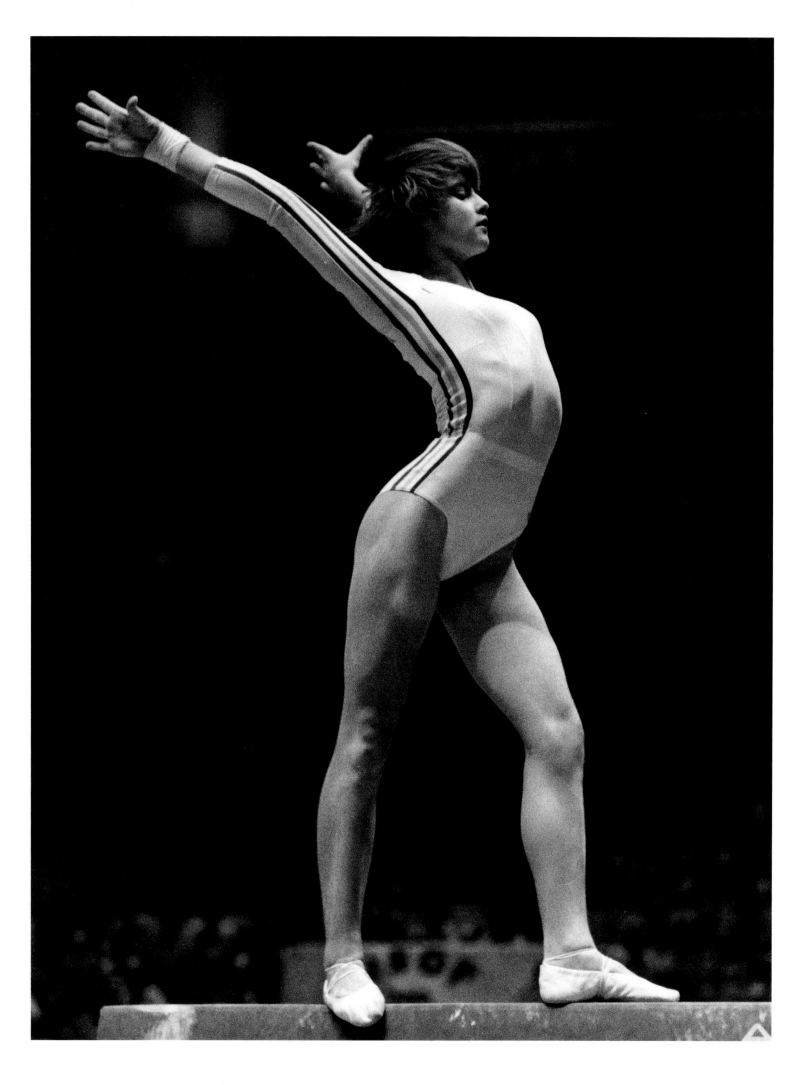

Rafer Johnson in the shot put. Olympic Games, Rome, 1960.

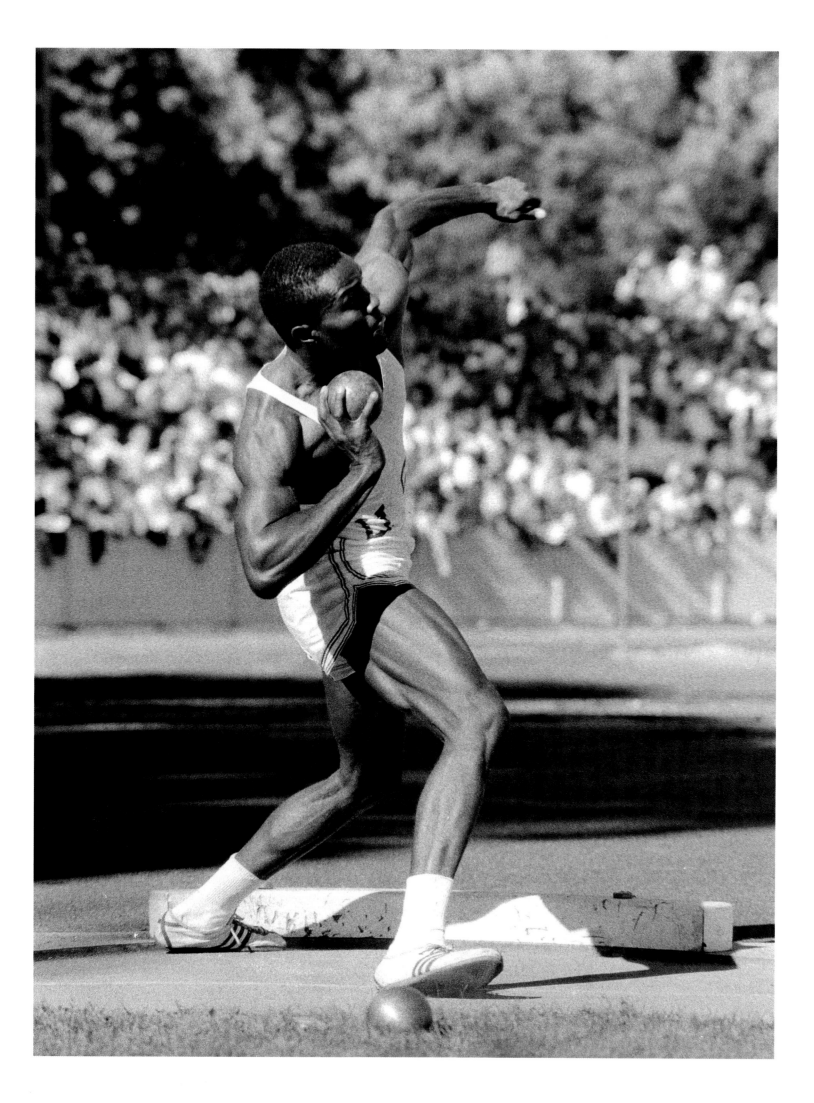

Edmonton Oiler goalie Grant Fuhr.

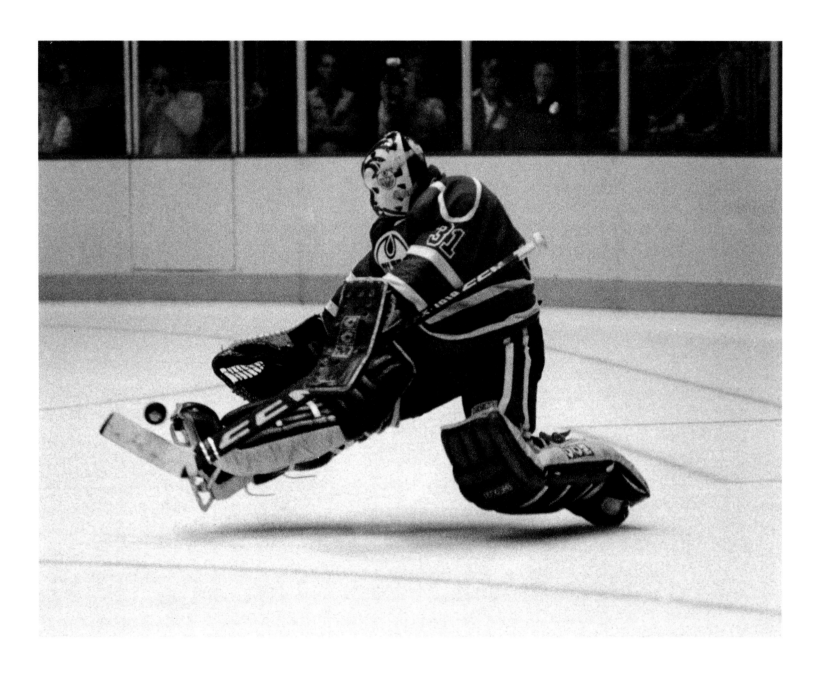

Montreal Canadiens' Maurice (The Rocket) Richard, 1957.

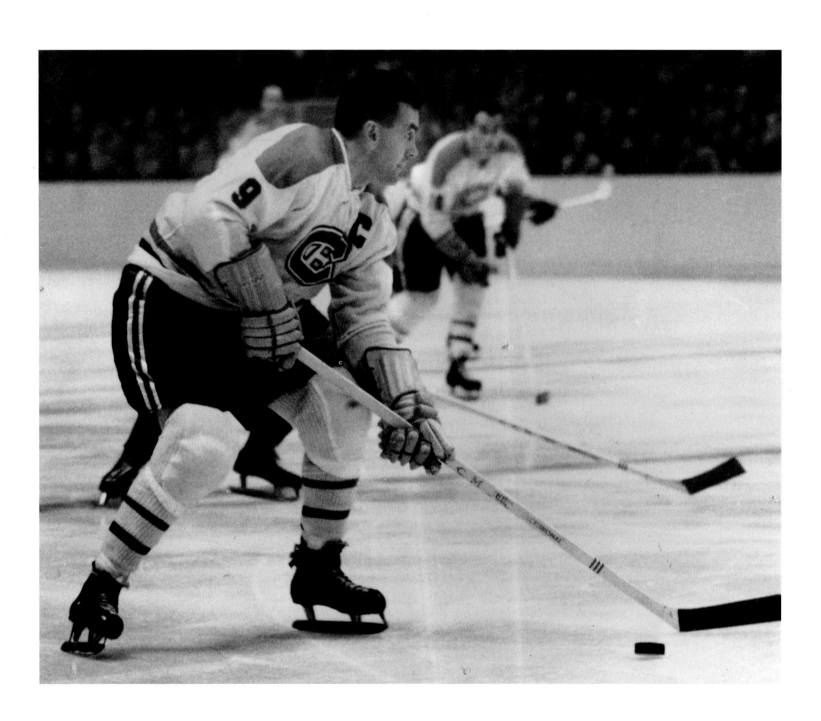

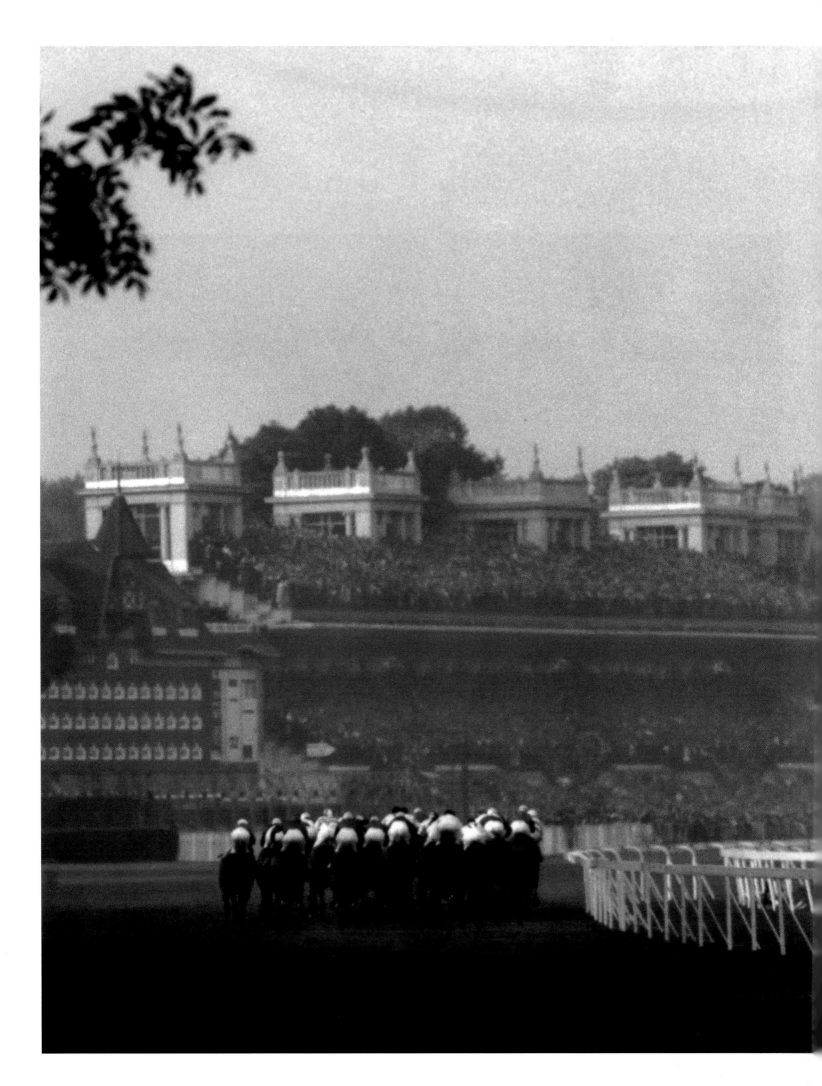

Seattle Slew, with rider Jean Cruguet, finishes first at the Kentucky Derby. Churchill Downs, 1977.

Preceding pages: Prince Royal, a seventeen-to-one long shot, wins the Prix de l'Arc de Triomphe, Longchamps, Paris, 1964.

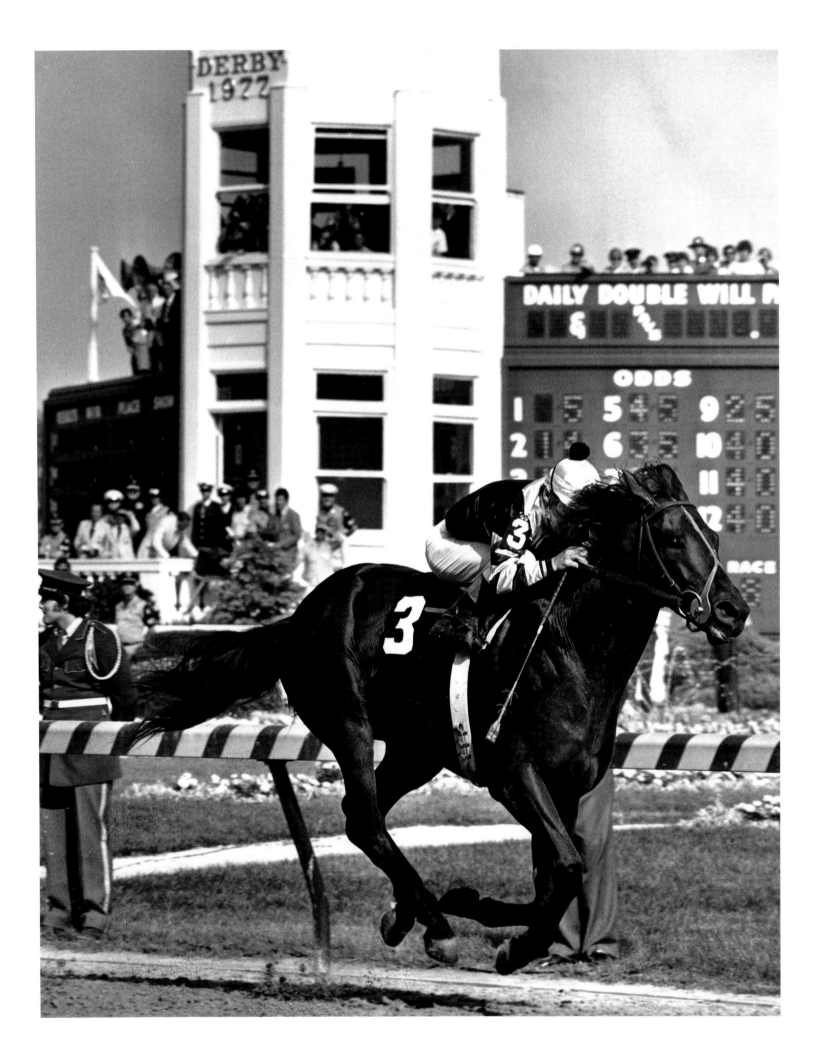

Tony DeSpirito.

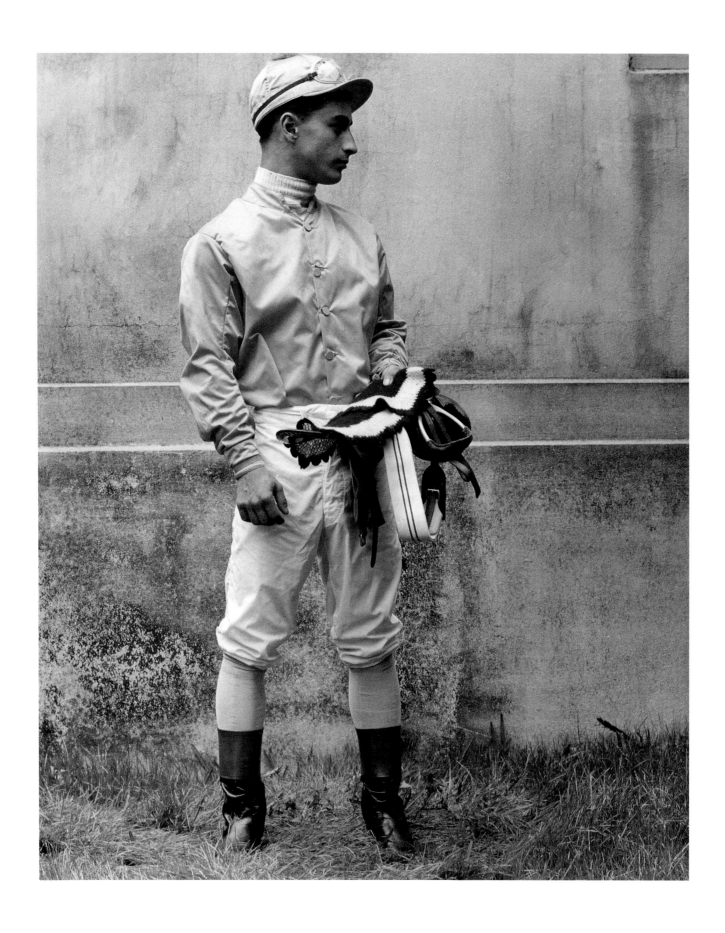

Lake Erie after colliding with Eddie Arcaro's horse in the Belmont Stakes. 1959.

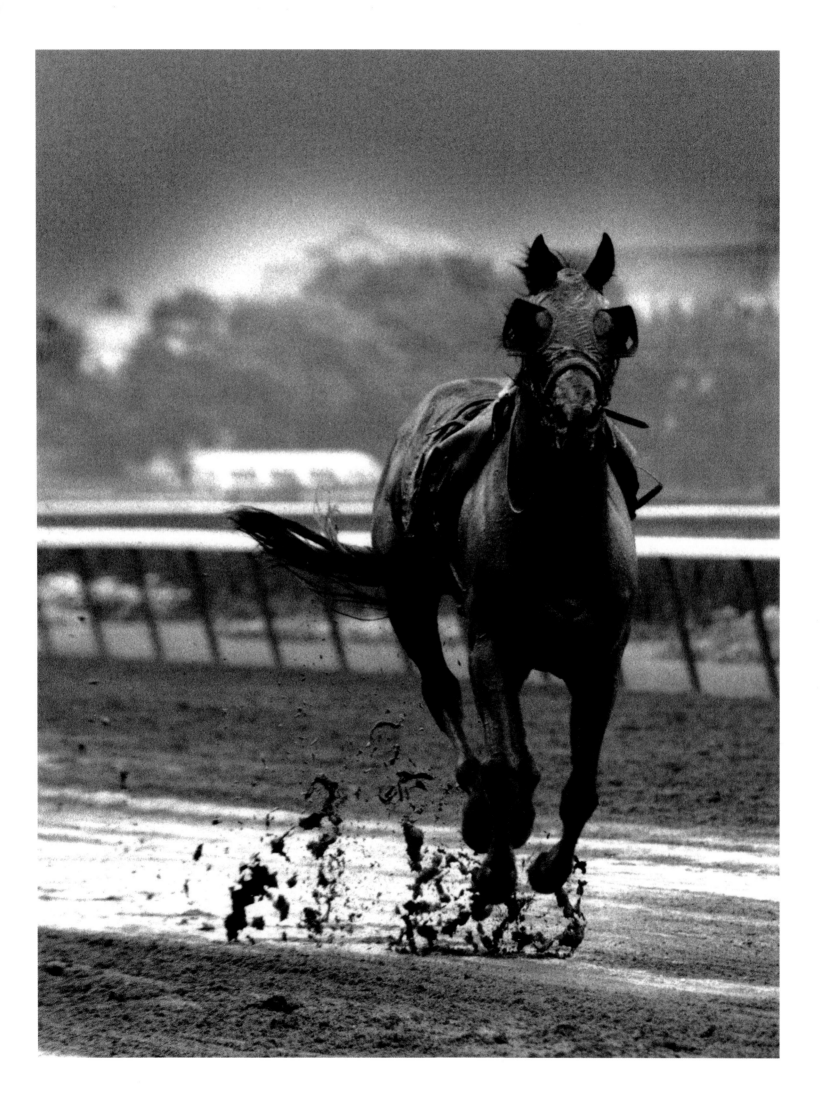

Exhibitions

"The Pros," one-man show, Art Institute of Chicago, 1961

"The Horse," one-man show, Art Institute of Chicago, 1962

Black-and-white photographs of NFL football, one-man show, Bankers Trust, New York, 1963

"The Photographer's Eye," group show, Museum of Modern Art, 1966

"Man in Sport," group show directed by Robert Riger, Baltimore Museum of Art, 1967
 Traveled to New York, Chicago, Portland, Houston.

"Photography in America," group show, Whitney Museum of American Art, 1974

"The Athlete," one-man show, Art Institute of Chicago, 1977
 Traveled to Los Angeles, Kansas City, Lake Placid.

"The Quiet and the Glory," one-man show, Sports and Entertainment Gallery, Venice, California, 1990

"The Sports Photographs of Robert Riger," one-man show, James Danziger Gallery, New York, 1995

Books

The Pros: A Documentary of Professional Football in America,
 with commentary by Tex Maule (Simon and Schuster, 1960)

Best Plays of the Year, NFL (Prentice-Hall, 1962)

Best Plays of the Year, NFL (Prentice-Hall, 1963)

The American Diamond, Branch Rickey with Robert Riger (Simon and Schuster, 1965)

ABC Wide World of Sports (American Broadcasting Company, 1965)

ABC Wide World of Sports (American Broadcasting Company, 1966)

Man in Sport (Baltimore Museum of Art, 1967)

The Athlete (Simon and Schuster, 1980)

The Sports Photography of Robert Riger (Random House, 1995)

Afterword

Drawing is the only thing I look for in a picture. If the drawing is not there I pass it by. When I take a photograph during a football game I am making an illustration, a representation of that game and of all football too. As in any art, the photograph must transcend the actual fact. The universality of the picture, its intimate yet heroic scope, will give it clarity and strength. Art needs conviction. You have to believe that a young baseball player sliding into third base on a steal and losing his cap is the subject of art, that art is fixing an image in a ballpark in Brooklyn where a few thousand people are watching on a Wednesday afternoon. I have been working on my vision of sports for almost fifty years. It really is a remarkable subject. You just have to keep working at the sports you care about, searching for clarity and simplicity. That is where the strength is.

I have had a sense over the years that in some photographic circles, sports photography is thought to have to do mostly with luck or circumstances. That of course is just dumb. There are no accidents in photographing sports. You know exactly where the ski racer will fall, where the car racer will spin out, where a racehorse will go down. Energy and passion will get you there. You are in position for the picture you want because in your conceptual design of the action, balanced with the style and skill of the athlete at that moment of the game, there is only one position. Yours. Someone seeing your picture must believe there was no other position, no other point of view. Your work describes the way it was.

Robert Riger
Huntington Beach, California
April 1995